Amisos

Abdera
SAMOTHRACE

THASOS

Ilion (Troy)

Assos

LEMNOS

Pergamon

LESBOS
Myrina
Kyme Sardis
Eretria
Smyrna
CHIOS
Ephesus
Brauron
SAMOS
DELOS Priene
Miletus
PAROS CALYMNA Halicarnassus
NAXOS Cnidus
 Xanthus
COS
Ialysus
Camirus Lindus
THERA
RHODES

Tarsus

Salamis (Enkomi)

Kition

Curium Amathus

CYPRUS

Knossos Olous
Axos
Petsofa
Gortyn
CRETE

Sidon

Alexandria
Naucratis

FAYOUM

CLASSICAL TERRACOTTA FIGURES

61 Head showing melon
coiffure. Boeotian (Tanagra),
c. 330–200 BC.

"Despise *me,* Mercury, because I'm only clay!
 Cheap product of the potter's art.
 I glory in my humble birth, and say
 'I only saw the humble giver's grateful heart.' "
 Anthol. Palatinus xvi. (Appendix Planudes) 191.

"For they (the image-makers) use a mould;
 and whatsoever clay they put into it comes
 out in shape like the mould."
 Dio Chrysostomus (Orationes 1x.25).

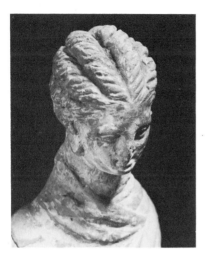

CLASSICAL TERRACOTTA FIGURES

JAMES CHESTERMAN

With a foreword by *R. A. Higgins*
Deputy Keeper of Greek and Roman Antiquities
in the British Museum

WARD LOCK LIMITED·LONDON

To Shirley, Pippa, Mark and Giles

© James Chesterman 1974

ISBN 0 7063 1878 1

First published in Great Britain
1974 by Ward Lock Limited, 116
Baker Street, London, W1M 2BB

Designed by Andrew Shoolbred

Text filmset in Bembo by
V. Siviter Smith Ltd., Birmingham

Made and printed in Great Britain
by William Clowes & Sons Limited,
London, Beccles and Colchester.

CONTENTS

FOREWORD

It is a great pleasure to introduce a book on a subject so near my heart. I have been studying Greek terracottas for over 25 years, and for the latter part of that time I have known Mr Chesterman and watched his collection grow.

Few people collect terracottas, but those who do rapidly fall a victim to their seductive charms. They may seldom be great art, but (to the addict) they have an attraction and an intimacy all too lacking in more formal work of marble or bronze.

It says much for the range of Mr Chesterman's collection that he is able to supply some two-thirds of his illustrations from his own resources. And it says much for his generosity that the cream of this collection is destined in the fullness of time for the British Museum.

R. A. Higgins

ACKNOWLEDGMENTS

Amongst the many people who have helped me prepare this book for publication, I should like particularly to thank the following.

For helpful advice on the manuscript and provenances of the terracottas illustrated: Dr Reynold Higgins, British Museum, London; Dr Herbert Cahn, Münzen und Medaillen A.G., Basle; Mr Charles Ede, Charles Ede Ltd., London; Miss Felicity Nicholson, Sotheby & Co., London.

For reading and supplementing the passage on Preservation: Mr David Akehurst, British Museum, London.

For reading the passage on T.L. tests: Dr Stuart Fleming, Research Laboratory for Archaeology and the History of Art, Oxford.

For sympathetic encouragement: Herr Herbert Hoffmann, *Museum für Kunst und Gewerbe,* Hamburg; Madame Simone Mollard-Besques, *Musée du Louvre,* Paris; Mr Cornelius Vermeule, Museum of Fine Arts, Boston.

For permission to reproduce photographs: all those Museums named in the list of plates; the late Lady Norton; Mr James Bomford; Girton College, Cambridge.

For permission to reproduce the end-paper map of the Greek World: Messrs Methuen Ltd, London. This map first appeared in *Greek Terracottas* by R. A. Higgins, Methuen, 1967.

For permission to reproduce the line drawings of Greek dress and hair styles: Folio Society Ltd, London. These drawings first appeared in *Greek, Etruscan and Roman Pottery and Small Terracottas* by Felicity Nicholson, Folio Society, 1965.

For the co-operation forthcoming from all good publishers: Diana Briscoe, Michael Raeburn, the late Gerry Speck, all of Ward Lock Ltd, London.

For untold patience in taking and re-taking photographs: Mr E. H. Greenwood, London.

For innumerable cups of tea and great forbearance: my wife.

INTRODUCTION

What is this *malaise* of collecting that assails some of us? Is it the lure of possessions, a squirrel instinct, for investment, to impress one's friends, or what? Terracottas started to captivate me ten years ago and during that time I have been able and fortunate enough to assemble a representative group of such figures. The best of these form seventy of the hundred black-and-white illustrations in this book, and the colour plates are all from my collection.

Terracottas are often beautiful, occasionally ugly, but they invariably communicate to the viewer the intimacy inherent in their conception. They were modest objects intended for the home and for religious votive purposes. They were produced *en masse*. Terracottas were rarely intended to impress, as were Greek bronzes and marble statues, nor did they cost as much. They were the poor man's representation of his deities and, to a lesser extent, of his secular way of life two thousand and more years ago.

Before I describe terracottas and their function I ought to say that this book has been a labour – of love certainly but also of duty. A labour of love because any group of objects, be they matchbox lids or tin whistles, that has been sought out and captured over a period of years needs to be encapsulated in some form. I do not think one should just lock one's possessions up in cabinets and gloat over them in privacy; they should sally forth into the world and be shared with others. So this book is also a labour of duty and will, I hope, allow my collection of terracottas to be enjoyed by a greater number of people than just myself and friends who are given the Greek tour of my cabinets.

Kenneth Clark expressed something of this urge to share one's works of art better than I can: 'I believe that the majority of people really want to experience that moment of pure, disinterested, non-material satisfaction which causes them to ejaculate the word "beautiful"; and since this experience can be obtained more reliably through works of art than through any other means I believe that those of us who try to make works of art more accessible are not wasting our time.'[1] Of course 'accessible' is the key word here.

Terracottas have captivated me for ten years and I seek to share my enthusiasm for them by writing a book which is, incidentally, ad-

[1] *Art and Society*, Cornhill Magazine (Centenary Number 1025), London, 1960.

dressed to the general reader and collector rather than to the scholar. More scientific books than mine on terracottas can be found in the bibliography but I believe mine to be the only book which introduces the subject specifically to the collector. But to return for a moment to my opening rhetorical questions, what is the ethos of collecting? I believe it can be motivated by any or all of those *raisons d'être* I mentioned – possession, hoarding, investment, conceit – none of them perhaps individually bad but collectively somewhat odious. Or again it can be as intangible as John Hunt's reason for climbing Everest: 'because it was there'. This gets closer to the truth, for me anyway. People ask me how and why I started collecting terracottas. It was 'because they were there' and few other people seemed particularly interested in them. Browsing through the rooms of the British Museum for long hours looking at these miniature portrayals of Greek gods, people and customs, and marvelling at the living quality of the clay modelling, I suddenly became aware that these little embodiments of classical life two to three thousand years ago could be bought for quite reasonable amounts and, hey presto, I started collecting them. My first purchase was a tiny Sicilian head of the fifth century BC for £2 in the Portobello Road, which, like an idiot, I later sold, but the knowledge that one could find such beautiful ancient things enthralled me, and still does. Then I graduated to buying through dealers specializing in antiquities, and although my second purchase proved to be a fake (plate 99) this did not deter me, and little by little the collection grew. Terracottas were, and still are, in fairly plentiful supply, and I started to study the subject in earnest and seek examples representative of the periods and regions.

In a remarkable book on the history of collecting in Great Britain the author complains that 'most collectors were poor authors and did not consider a detailed account of their own activities worth passing on . . . It is these rare moments of personal selection from a mass of seemingly similar objects in an auction room, gallery or shop, which precede acquisition which are the real highlights of a collector's career and – sadly – most of them hardly ever find their way into books or catalogues.'[2] I hope to redress this balance in a small way by describing episodes that involved buying terracottas and the criteria I adopted in choosing my figures, but I suppose the main aesthetic consideration that guides me in collecting is what I term 'the authentic bump'. This is when the blood starts to race in one's veins on being confronted by an object in the knowledge that, at first sight anyway, it is desirable and merits attention. There is a pounding in the temples and your heart may even miss a beat (hence the word 'bump') as you turn the object over. Take your time. Try to decide whether the 'bump' is 'authentic'.

[2] *The English as Collectors* by Frank Herrmann, Chatto & Windus, London, 1972.

It is authentic if, after several minutes, your first impression of quality in the object still remains. Is it beautiful? That is, does it please your eye and continue to do so? Turn away from it and gaze into the middle distance for a few moments, wheel round and take it by surprise. Does it still engender the same 'bump'? If not, beware, because your steadying heartbeat may mean that the object of your previous desire will be a dull thing in your own home. Be your own judge in deciding whether something is beautiful, to you and to no one else. Aesthetic appreciation is an entirely personal thing; beware of the dealer who disagrees with your view and continues to press an object when your impulse is to reject it. This means he is only a salesman and does not understand the variety inherent in human responses to beauty.

Beware too of fashion. She is a fickle lady and may elude you amongst the throng of her admirers or, worse still, she may be *passée* by the time you catch up with her. Many is the time I have come upon an object that has been overlooked by buyers because it does not catch the mood of the moment. Disregard the *zeitgeist*. The greatest thrill in collecting is to play the game in your own time, not that of the masses.

Aesthetic appreciation must be the predominant factor in forming a collection of any group usefully called art objects; herein lies the joy, the flair, and in Kenneth Clark's phrase 'causes them to ejaculate the word "beautiful"'. But clearly there are other criteria that you must apply. Authenticity is the first of these and I have covered this in chapter 7. Then, does the object fill a gap in your collection? If so, and it is beautiful and provides you with your 'bump', you will probably buy it. If it duplicates something you already possess, is it better and should you discard the first in favour of the second? Terracottas in particular are often quite similar within particular groups because they were produced in large quantities and from moulds. So one should seek constantly to exchange and improve one's collection. Little by little it grows and changes as your own knowledge and appreciation sharpen into connoisseurship; your collection should be a living entity, not a dusty storehouse.

Nor, I think, should it necessarily be a treasure-house. People who show me their collections and gleefully quote the purchase price of each object with today's higher value, all in the same breath, are investors in art as distinct from *bona fide* collectors of works of art. There are, alas, more of the first than the second *genre* nowadays, in the flight from money into property, especially in the fields of *grand art,* but the history of art collecting produces many instances of the men and women who selected a subject that moved them for aesthetic rather than financial reasons. Their collections were built out of love for the subject rather than for investment and, in consequence, their collections were invariably better balanced.

It follows that the price of an object should be the very last consideration. If it is good, and you like it, need it and can afford it, buy it. Haggle over the price certainly (*marchander* is the prettier French word) if you think it is excessive, but do not miss the object for the sake of a few pounds. You always remember the objects that you failed to get and which, in retrospect, you know to have been necessary for your collection. You rarely get a second chance.

In your earlier days of collecting avoid the 'collector's piece'. These are the unusual objects just outside the mainstream of the subject, the side eddies of the *oeuvre*; beware of them because you will probably be out of your depth anyway and may be taken in by a fake–the forger frequently embellishes. You should stick to typical examples and so build your collection and your knowledge along safer lines. Collectors' pieces come later on when you can recognize the good from the bad, and when your palate is ready to be titillated by the unusual.

So to the final reasons for forming a collection. I believe it is a creative activity. You apply your knowledge and flair to assembling objects that, grouped together, form a work of art in themselves. It is as though you have painted a landscape and included in it just those details that please you (and only you) so that, at the end, your canvas is as perfect as you personally can make it. Like all good painters you erase, replace, alter the details until you are satisfied. Collecting is also very exciting. You are pitting your wits against the world and, depending on the subject that inspires you, the world is your oyster. You always enter any shop or auction room that may contain the objects of your desire, you receive sale catalogues from all over the world, you take busman's holidays to countries whose museums and dealers may teach you or sell you something of value. And lastly, to end this apologia, there is the satisfaction of passing on to your children a collection that may, in turn, be added to and enriched, or you can leave it to a museum. Tax laws now recognize the merit in removing death duties on objects left to museums, as well they should, for a nation's heritage lies just as much in its culture as in its castles.

This book attempts, then, to describe how, why and where ancient classical terracotta figures were made during the span of two and a half thousand years between *c.* 2000 BC and AD 500. Terracottas, as these little statues are generally called, tell us a great deal about the ancient Greeks and Romans; their portrayal of people, dress and everyday occupations provides us with a direct insight into the civilizations that founded the western world.

Terracotta, of course, means fired clay, and the figures were made in three principal ways. The first primitive method, used during the period *c.* 2000–700 BC, was to model solid figures by hand (e.g. plates

14

3–11). The second method, between *c.* 700–500 BC, was to make a hollow shape on the potter's wheel and fashion it, also by hand (e.g. 12, 13). From *c.* 600 BC onwards, the third and most effective method of all was developed, of using moulds. Some interchange between all three methods existed, however, at most periods and some figures combined two or sometimes all three methods.

To make a mould, an original archetype *(patrix)* was first sculpted by hand either in wax or, more often, in soft clay which was then fired at a high temperature. Next, a thick layer of clay was pressed round the archetype and a hollow mould created which was, in turn, fired at a high temperature. Projecting parts and deep incisions had to be avoided so that the resultant figure separated cleanly from the mould. Often a mould was provided only for the front of a figure, the back being summarily dealt with, but, in the Classical and particularly the Hellenistic periods, the more refined terracottas were often built up from a number of separate casts. Some of the larger erotes and figures from Myrina in the second century BC had up to fifteen different parts.

Examples of moulds and impressions are shown below. The British Museum example (1) is a fine mould and the resultant impression is very clearly defined. My own mould (2) of an actor is less spectacular but does show that he was cut off above the knees; the legs would therefore have been added later from another mould.

To make a terracotta, thin layers of soft clay (impregnated, if necessary, with sand or grit to slow down contraction) were pressed into the mould to a thickness of up to $\frac{3}{16}''$ (5 mm) with the thumbs and fingers to get a good impression that would echo the original in all its detail. These thumb marks can often be seen. When dry, the hollow impression shrinks and can easily be lifted out of the mould. If a figure was to consist of several different parts, these were moulded, then assembled later in their dry state and stuck together with moist clay. A vent hole (67) was usually provided at the back and figures were also sometimes open-based to allow the expanding air to escape in firing (otherwise the figure might crack and distort). After firing, some terracottas had their holes filled, Attic figures especially. Bases were often added to stabilize the figures and almost all Tanagras (59–66) have this feature. The height of terracottas was usually 4–8″ (10–20 cm).

After incising any finer details with a pointed tool, and adding any projecting parts, the soft terracotta figure was covered with a white 'slip' of dilute clay and fired in a kiln to a temperature of 700–950°C. When cool the figure was usually painted in bright colours (marble statues were also, incidentally, painted in similar bright colours). Red and blue were the chief colours but green, white, yellow, pink, black and sometimes gilt were also used. White was often used for the female face, red or pink for the male, and gilt for earrings and goddesses' head-

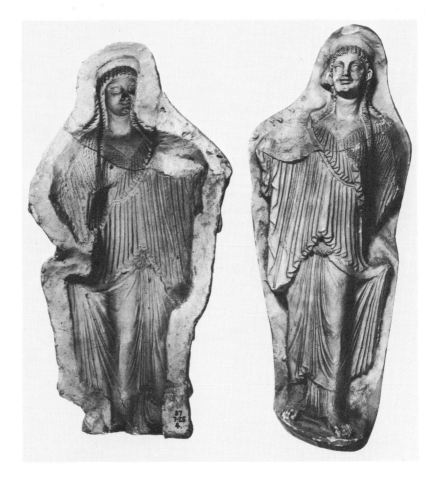

1 Clay mould with modern plaster impression. Tarentine, *c.* 100 BC. Height 24.5 cm.

dresses. The other colours were used for apparel. Not being fired, these tempera colours are fugitive and very few figures today have much colour left on them. Even the white slip is something of a rarity and this explains why most terracottas are reduced to their original clay. Terracottas recently excavated sometimes have their colours intact below the dirt but they tend to fade in the light and air. The two Alexandrian ladies (68,69) were passed on to me, in 1965, by a man who had excavated them himself in Alexandria in 1921 and he told me the colours had faded during the years. It is sad that soft, muted shades are all that have survived. Some early terracottas (before *c.* 500 BC) were 'glazed' inasmuch as they were fired and these colours have lasted very well. 'Glazed' figures are rare and are often vases (known as 'plastic' vases) in the shape of figures. Plastic vases are outside the scope of this book.

A mould could only produce a limited number of copies, then lost its definition of detail and had to be scrapped; so although one may describe terracottas from moulds as mass-produced, this is a relative term

16

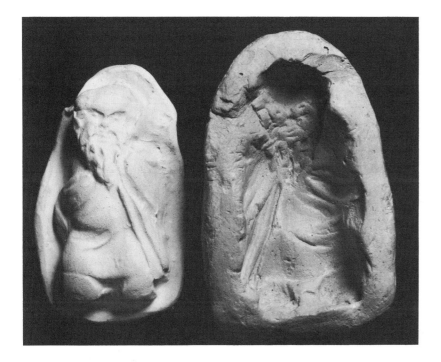

2 Clay mould with modern plaster impression. Attic, *c.* fourth century BC. Height 6.5 cm.

and it is rare indeed to find two exactly the same. Occasionally one finds terracottas with identical torsos but with different legs, arms and heads added. Sometimes, rather charmingly, figures occur with the same limbs but stuck on at different angles, achieving variety without extra moulds being needed.

Moulds, and therefore terracottas, vary enormously in incisiveness of detail. They are often copies of copies in the sense that a new mould would be taken from an actual figure. Obviously some sharpness of definition was lost each time this was done and moulds became progressively smaller because, as I have said, the figure shrinks in drying (about 10%). Archetypes were jealously guarded (and sometimes signed on the back), often only the figures were sold so these were copied with dire results. Plaster moulds became common in Roman times and lasted longer.

The craftsmen who made terracottas were called coroplasts (*koroplathos,* dollmaker, in the Greek). Their workshops frequently made and sold other articles such as vases and toys, and their equipment included ovens which were made to retain the considerable heat needed to fire the clay. A few workshops have been excavated and, in important centres such as Corinth and Tarentum, a great quantity of original moulds were found. These, and terracottas themselves, were exported from these main centres to countries all over the Greek world. This makes find spots sometimes misleading. A figure found in Sicily may

well have been imported from Athens, or it may have been made in Sicily using local clay and an imported mould, or it may be an entirely local product. Or again it may have been made locally by an itinerant Greek coroplast from the mainland who plied his trade in Sicily. All this makes accurate attribution difficult, although the texture and colour of clay varies a great deal and helps us to identify regions. Style, of course, also helps. One can usually be fairly certain of the region of a terracotta before the Hellenistic period (i.e. before *c.* 330 BC) by judging both clay and style but, after that date, a greater conformity sets in and we find similar styles and subjects being produced all round the Mediterranean basin. There are, nevertheless, subtle differences in conception that add excitement to the detective work.

Now, the essential question, why were terracottas made and what was their purpose? This becomes clearer when we understand that terracottas could be mass-produced and were the artefacts of the poor. It is believed there were several uses for terracottas, both religious and secular. In antiquity, the dead were often buried with their most prized possessions to accompany them into the next world and excavated tombs frequently reveal the terracotta ornaments and toys enjoyed by the living, as well as votive offerings and gifts from friends of the deceased. Clay terracottas were available in quantity and were relatively cheap, more modest than marble or bronze statuary, and manufactured by humble craftsmen often with their workshops close to burial places and shrines. Mourners could buy terracottas for the funeral rather as we buy wreaths of flowers today.

Reproductions of gods were common and we find a number of Greek deities being represented throughout the centuries: Demeter, Aphrodite, Dionysus, Eros being among the most common. These representations of gods were obviously religious in character. Occasionally terracottas were only funerary in purpose and the early mourner (17) is an example. It is also believed that, in pre-Hellenistic times, terracottas were substitutes for sacrifices beside the dead; early tombs sometimes showed evidence of secondary corpses, human (probably slaves or prisoners) as well as animals such as horses, pigs and bulls. This drastic form of sacrifice to the gods was probably replaced later on by burying clay substitutes representing both humans and animals in the graves.

Terracottas have been discovered in large quantities buried as votive objects in trenches near temples and sanctuaries. They were usually broken up on purpose by the priests so that the donors' offerings could not be salvaged and used again. This, apart from their fragility, explains why so many fragments abound and heads are common (91–92). Children's graves reveal a preponderance of toys and dolls, a cavalryman might be expected to have statues of horses and riders, an actor

have masks and miniature actors, a housewife have *genre* figures showing her at her cooking pots or in the farmyard, an athlete be shown in some heroic stance. Examples of all these can be found in the illustrations. Find spots include private houses where both secular and religious figures have been discovered, serving both as domestic objects and as religious deities to worship. Religious subjects border closely on the secular as did, in fact, all of Greek life; gods were the images of men and vice versa and terracottas too are inextricably mixed in their portrayal of deities and people. The exact purpose and meaning of terracottas are not known to us and a great deal can only be surmise, but they are one of the best visual records available to us of how the Greeks and Romans lived (painted vases are another record).

From the fourth century BC onwards, the more secular tendency accelerates; the graceful ladies and young men from Tanagra (59–66) who pose so effectively are clearly less concerned with worship of their gods than with their own self-esteem. Late Hellenistic terracottas progressed in artistic development and sometimes echo large marble statues. The Crouching Aphrodite from the Paul Getty Museum in Malibu (86) may be a copy of an earlier work. Second and first century BC figures from Myrina often take for their inspiration the work of Praxiteles and other famous sculptors who were carving their marvellous works two hundred years or so earlier. Occasionally we find portraits – *surely* plate 54 is Sophocles? Young women predominate in terracotta figures; next come men, youths, children, toys, animals, birds, and fruit. The dominance of females may stem from the ancient and traditional belief in woman as 'earth mother'.

Modes of dress and hair styles were reproduced in sophisticated detail. The Greeks and Romans took a great deal of care over their appearance and wore fine clothes, jewellery, perfumes and cosmetics and spent much time over their hair. Fashion was as fickle then as it is today and, although choice was admittedly more limited, the Greek maidens from Tanagra in their simple clothes exhibit charm and dignity in abundance.

The *Doric Peplos* (figure 1) was the earliest garment after the end of the Mycenaean era. It was sleeveless, folded to give an 'overfall', and made of wool. The peplos was pinned at the shoulders and usually girdled at the waist.

The *Ionic Chiton* (figure 2) followed *c.* 600 BC and being made of linen it followed the contours of the body more faithfully. There was no 'overfall', sleeves were added, and it was girdled at the waist to produce a form of pouch which could be worn long or short and which regulated the length of the dress. Chitons of the fourth and third centuries fitted the body more closely and were commonly girdled under the breasts.

Figure 1 The Doric Peplos

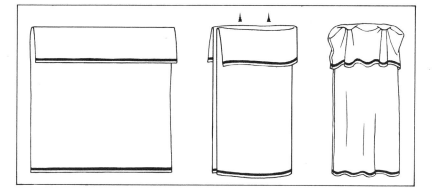

Figure 2 The Ionic Chiton

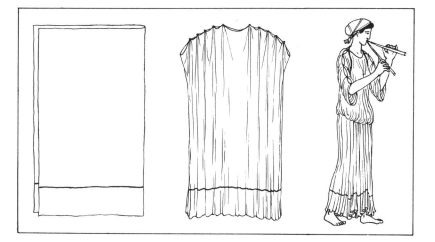

Figure 3 The Himation

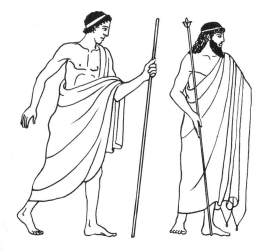

Men wore mainly the *Himation* (figure 3) which could be drawn over the head as a cloak or could be worn in one of the two ways shown. From the fourth century BC and in Hellenistic times, women often wore both the chiton and himation together.

A more practical dress for young men and warriors was the *Chlamys* (figure 4), a short cloak fastened by a brooch at the right shoulder and often worn with a sun-shading hat known as a *Petasos*.

Intricate hair styles developed throughout the centuries. The *Polos* (figure 5) was the earliest and was really a cylindrical head-dress worn by deities (49 is a good example from the fifth century BC). Later styles included wearing the hair up, sometimes with a band of cloth (figure 6) or with a centre parting (figure 7). The 'melon' coiffure, sometimes with a top-knot but more often without, is a common and attractive style from the late fourth century BC and must have taken hours of preparation by a lady's slaves (61). Where paint survives on terracottas, the hair is sometimes red, sometimes yellow. The ancient books tell us that yellow was considered rather 'racy' and progressive–the dyed

blondes of antiquity, as it were. *Plus ça change* . . . Men's hair was usually worn long at the back and sides, and beards were common in older men. Young men were mostly clean shaven.

Terracottas were made all over the classical world and the endpaper maps show the main centres. Before 1850 only relatively few figures had been excavated as museums and collectors preferred marble and bronze statues; but between 1850–80 the trickle became a flood as digs increasingly revealed terracottas, culminating in 1870 in the first Tanagra figures discovered (and pillaged) by peasants in this little town of Boeotia, a district north of Athens. For the first time the public were made aware of the excellence to which terracottas could attain, and 'Tanagra' has become a generic term for all terracotta figures irrespective of their period and provenance, misleadingly as we shall see.

The nineteenth century was the age of enthusiastic freedom in archaeological digs when men such as Schliemann, Arthur Evans and Cesnola were at work, and less well known but equally dedicated men were unearthing terracottas that were to find their way into museums and collections all over the world. Nowadays, fortunately in my view, this freedom is circumscribed. Countries like Greece, Italy and Turkey are seeking legislation through UNESCO to forbid the sale elsewhere of objects, from clandestine digs, that are smuggled out and not given a *bona fide* export licence. This must be right. The heritage of all the ancient worlds has been ransacked for too long and the penalties for improper activities are nowadays very severe and include long prison sentences in the countries where clandestine digs occur. Collectors, dealers, auction houses and museum curators can all play their part by not handling objects they know or suspect are 'hot', an attitude that has unfortunately not been too scrupulously observed up to now and which the new laws seek to contain. Authorized digs, on the other hand, have grown apace with excavated objects being carefully catalogued and displayed in the national museums of the countries in which they are found. Exciting new discoveries are being made every day and new styles and types discovered. The future in all archaeological fields is bright as conservation becomes the watchword and governments combine to stamp out the smuggling that has increased with the rising values in antiquities.

But this does not mean that terracottas can only be collected by taking a spade and digging by moonlight in a quiet corner of Greece. Woe betide you, in fact, if you do! When visitors see my figures in their cabinets, they usually ask where I have obtained them and are surprised to learn they are not smuggled, but that they have been bought from salerooms and *bona fide* dealers. During the nineteenth century and the beginning of the twentieth, literally thousands of terracottas were excavated and passed into public and private collections. The private

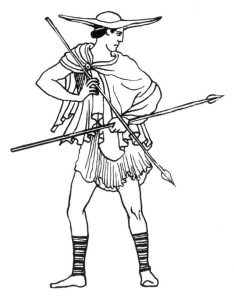

Figure 4 The Chlamys and Petasos

21

Figures 5–7 Hair styles

pieces change hands frequently through 'the trade' and great collections are sometimes dispersed and sold through the auction rooms, when they are catalogued as 'the property of Mr X', and invariably fetch high prices because of the famous name. But a collection is not built up by just out-bidding everyone else at an auction. It is a painstaking and very personal activity with the collector invariably buying pieces singly; those who buy in bulk normally regret it as there will inevitably be chaff amongst the wheat. It is a very personal activity because a collector is influenced by his own taste and knowledge and his pieces accumulate according to his own particular flair. The seventy black-and-white illustrations and those in colour, which are from my collection and reproduced in this book, are chosen as examples to illustrate the periods and regions of terracotta production, but another man's choice would be different and rightly so. Museum collections are obliged to try to cover the whole span of a subject, a private collector picks and chooses. Aesthetic considerations play a large part in a private collection, whereas a museum is often obliged to consider the scientific and historical aspects first.

My own collection has been put together in the last ten years or so from all over the world. Less than half has been bought in London. Other centres, where dealers specialize in terracottas, are Paris (where love of sculpture is traditional), Zurich, and objects can also be found in New York, Amsterdam and, indeed, most capital cities. A list of recommended dealers and auction houses will be found at the back of the book. Italy, Greece and Turkey are, of course, prolific in figures but the collector should beware that he is not being offered clandestine pieces or forgeries which abound, and he should always demand an authenticated invoice which he can show to the Customs. Forgeries are discussed in chapter 7.

Terracottas have, luckily, been out of fashion for many years and, although prices have risen, they have not rocketed in line with other antiques. I have been able to put together, without undue difficulty though admittedly with the good fortune to have travelled extensively, a collection that stretches from *c.* 1400 BC–AD 200 and covers most

regions and types, and this on a perhaps surprisingly slender purse. A small head can still be bought for about £20 and even a complete figure can cost less than £100. For a fine Tanagra, on the other hand, the collector must be prepared to pay up to £250 or even higher, but I venture to suggest that even this is cheap when compared to the prices asked for anonymous nineteenth century sculpture. Personally, I have never paid more than £250 for any figure and have found few bargains—I have just paid the market price.

Lists of prices fetched at sales at auction houses such as Sotheby's and Christie's can be purchased, the original catalogues are normally illustrated, and a combination of the two will keep you in touch with changing values. Always keep catalogues from past sales. The same objects crop up now and again and reference to the previous occasion will give you an idea how much you may have to bid. Do your own bidding at sales, if you are able to attend them. Mark your catalogue in advance with the maximum price you will pay though, if it is a very desirable figure, be prepared to go higher. Leave your bid with the sale-room if you cannot attend.

Classical art in all its forms is somewhat out of fashion today, perhaps strangely so when one considers that our cultural heritage is largely based on Greece and Rome. Perhaps a revival is overdue? The Renaissance rediscovered *ars antiqua,* so did the eighteenth and nineteenth centuries when neo-classicism was at its height. Art and architecture have a way of recharging their batteries at intervals through study and reinterpretation of the ancient world.

1 PREHISTORIC c.2000–1100BC

Crete (Minoan)

Before we can begin to use the term 'Greek' for terracottas, we must pass through the pre-Greek or Bronze Age periods, usefully known as Prehistoric, when the Cretans appear to have been the dominant people in the Aegean. Mainland Greece was backward indeed until the Mycenaean civilization began and we find the earliest terracottas in any quantity in Crete in the Middle Minoan Period, *c.* 2000–1600 BC. These first figures were entirely fashioned by hand and the figure of a man (3) would have been produced from a single lump of clay with appurtenances such as the dagger and codpiece added afterwards. The head (4, 5) probably dates later and is a marvellous example of restrained power. In its complete form, the figure probably had arms raised in supplication and was almost certainly a household goddess.

Mycenaea

No terracottas are known in the Mycenaean Period until *c.* 1425 BC, but, before the Dorian invasions of 1100 BC, the Mycenaean kingdom spread out from Greece itself to neighbouring lands, and individually modelled and stylized figures have been excavated in places as far apart as Sicily and Cyprus. The Mycenaean 'type' is abstract in form and

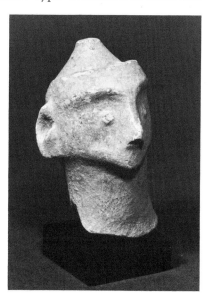

4, 5 Head. Minoan, *c.* 1400–1100 BC. Height 13 cm.

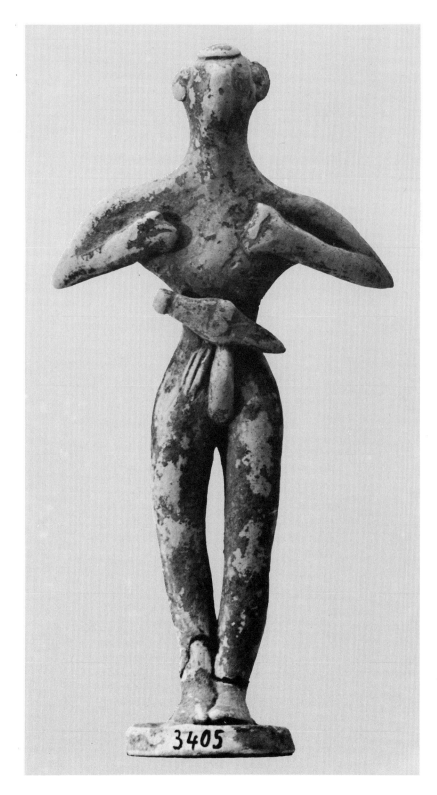

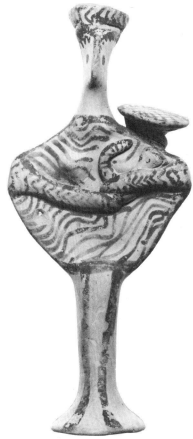

10 Standing goddess with child:
Mycenaean, *c.* 1400–1200 BC.
Height 13 cm.

3 Standing man. Minoan, *c.*
2000–1500 BC. Height 17.5 cm.

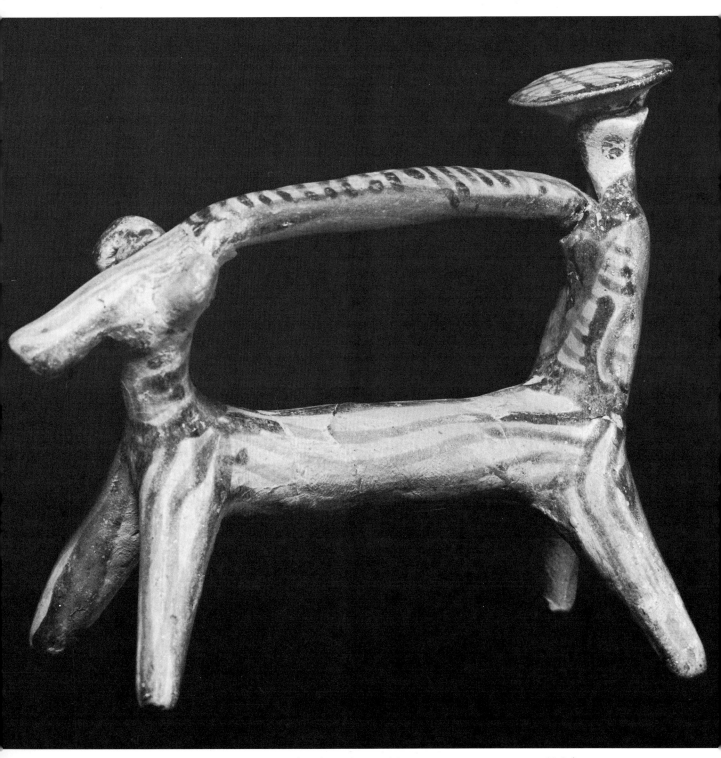

9 Ploughing Group. Mycenaean, *c.* 1400–1200 BC. Height 9 cm.

usually female. The three goddesses (7, 8) have been named after the Greek characters *Phi (Φ)*, *Psi (ψ)* and *Tau (τ)* which resemble their shape. They are decorated with black stripes which sometimes turned brown in firing (see colour plate), and are the most common types. Girdles and necklaces are summarily indicated. A slight variation in style occurs in the graceful goddess from the Peloponnese (6) whose fluid sculptural lines of the body are echoed in the wavy lines of decoration. More typical in style is the female (10) who is probably a goddess as well. This delightful woman and child, with its legs kicking in the air and head protected from the sun by a hat or canopy, is known to have been excavated in Mycenae in 1887-8; the modelling is amazingly free for such an early piece. It could be argued that the sun shield over the child's head is not a hat or canopy but rather a stylized head-dress, although I doubt this from the evidence of the ploughing group (9),

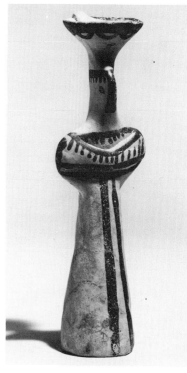

8 Standing goddess, *Tau (τ)*. Mycenaean, *c.* 1400–1200 BC. Height 10 cm.

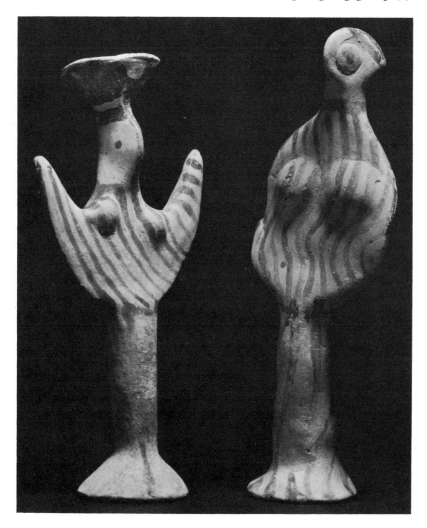

7★ Standing goddesses, *Psi (ψ)* left, *Phi (Φ)* right. Mycenaean, *c.* 1400–1200 BC. Heights 11, 12 cm.

27

where the man's head is topped with what must be a sun hat. The ribbon of clay running between the man and the animal (an ox) indicates a pole or reins.

Other Mycenaean groups include diminutive goddesses on thrones (11), tiny chairs and tables, animals, and wheel-made figures with the lower part of the human body turned on the wheel and the upper half modelled by hand. The goddesses (6–8) illustrated here are, in fact, solid throughout but their flaring bases may have indicated to later coroplasts the idea of the hollow cone. We shall come to this more particularly in the next chapter. Mycenae was destroyed by the Dorians in c. 1100 BC and the Dark Ages follow.

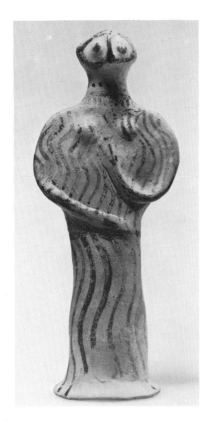

6 Standing goddess. Mycenaean, said to be from the Peloponnese, c. 1400–1200 BC. Height 16 cm.

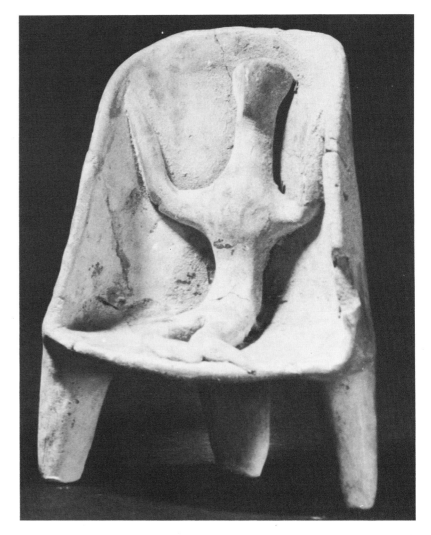

11 Seated goddess on throne. Mycenaean, c. 1400–1200 BC. Height 6.5 cm.

28

2 DARK AGES c.1100–650BC

Geometric

The Dorians not only destroyed the Mycenaean world but also wreaked havoc on most of the Greek people and their crafts. It was the Dark Ages indeed with little or no money for luxuries such as terracottas, and their production was virtually brought to a standstill until the eighth century BC. It is only in this century that a hesitant revival begins in what is, rather loosely, called the Geometric Period after the vases of that time which mostly came from Athens. These vases were decorated and glazed in a schematic system known as geometric and this system carried over into terracottas. The vase-like doll (12) from Boeotia is pierced at the back of the head for suspension and the legs swing freely beneath. They are attached separately, with cords, to the underside of the body which is turned on the wheel and is a hollow cone, a link perhaps with the flaring bases of the Mycenaean goddesses of several centuries earlier. These wheel-turned 'glazed' figures are generally thought to be dolls but they are also referred to as 'bell-idols' and, as their type appears to have existed for a century or more to the exclusion of other subjects, they may well have had a religious rather than a domestic connotation. Their heads, arms and legs were handmade. Boeotia was responsible for most of the few extant bell-idols.

Cyprus

A group from Cyprus (13), known as 'snowmen', was being produced in relative abundance. These are so named because of their elementary modelling rather as a child fashions a snowman, i.e. start with a lump and work upwards. These were also turned on the wheel, rather like their superior counterparts from Boeotia, and pierced for suspension. I think they are jolly little fellows with their peaked caps, pointed beards and stumpy arms, and the fact that there is a faint echo of the Mycenaean goddesses (compare particularly the *Psi (ψ)* figure with the smaller of the two Cypriot) may not be a coincidence. Cyprus survived the Dorian massacres better than other Mycenaean settlements because of its distance, and terracotta production in that island was a fairly continuous process. Plate 14 is entirely handmade and must be a mother goddess with her arms raised in benediction.

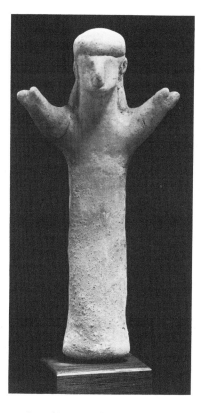

14 Standing goddess. Cypriot, seventh century BC. Height 19.5 cm.

29

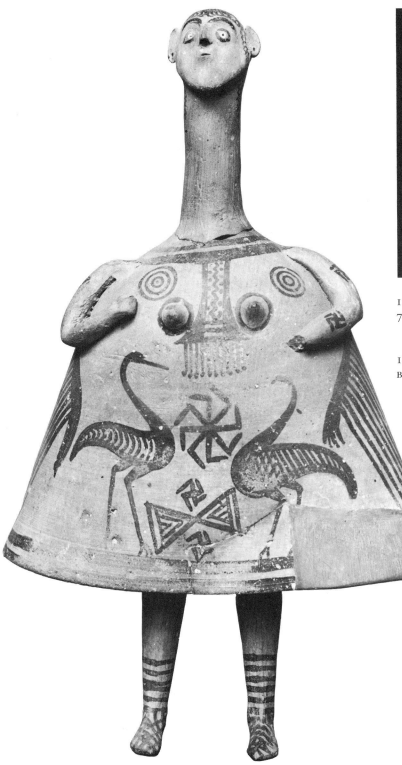

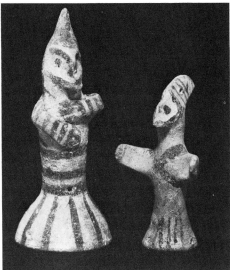

13 Two 'Snowmen' figures. Cypriot, *c.* 700 BC. Height 14, 10 cm.

12 Doll. Boeotian, late eighth century BC. Height 30 cm (without legs 23.5 cm).

Crete (Dedalic)

Terracottas continued to be made in Crete after the Minoan Period but it was not until the seventh century BC that their production was re-vitalized through the introduction of the mould. It is uncertain whether the first western moulds were made in Crete; they originated in the east, but Crete certainly used them extensively at this time. The in-novation of the mould probably reached Crete and Greece from Syria or Cyprus (or both) and this new technique for manufacturing terra-cottas made possible the mass-production of figures of increasing artistic merit. Cretan art produced, from moulds, the so-called Dedalic style, named after Daedalus, the legendary artist and craftsman who designed the labyrinth for King Minos. The style was undoubtedly much influenced by Egyptian art, and the typical Dedalic face (16) is somewhat triangular and has long ringlets of hair falling to the shoulders in a manner reminiscent of the Egyptian women. This style was echoed in various Greek lands with local variants.

The bodies of Dedalic figures were of solid clay, moulded in the front but flat on the back, and therefore known as plaques (15). They stand at the threshold of an upsurge in terracotta production, made possible through the invention of the mould.

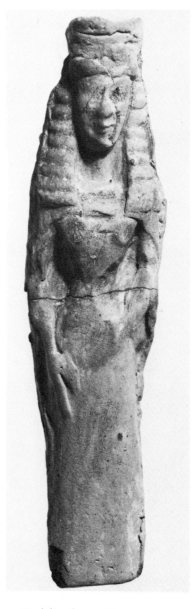

16 Dedalic plaque. Cretan, mid seventh century BC. Height 15 cm.

15 Dedalic plaque. Cretan, mid seventh century BC. Height 14 cm.

3 ARCHAIC c.650‑500BC

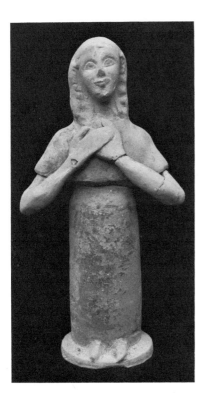

17 Mourning woman. Rhodian (?), early sixth century BC. Height 21 cm.

The introduction of the mould from eastern countries coincided with the orientalizing period of Greek art, when the Greeks increasingly engaged in commerce with Phoenician traders and were thus exposed to the more mature artistic developments of, for instance, the Syrians. The Archaic period followed in the seventh century BC with Greek artists taking the oriental artistic traditions and adapting and refining these into something characteristically Greek. The Archaic style sought to represent form as it is in nature and as seen by the eye. The statues in marble and bronze of this time were known as *kouros* (youth) and *kore* (girl) and the traditional pose for these was to be standing, somewhat stiffly with the left foot forward, arms to the side, hands clenched, and with a facial expression that is known as the 'archaic smile'. This smile irradiates the face and projects a reverence and joy. It is an expression that Leonardo da Vinci, Botticelli and other Renaissance artists would come to study and comprehend. The archaic expression of inner serenity may be seen in terracottas and carries through into the Classical period.

Rhodes and East Greece

The mourning woman (17) is probably Rhodian, yet retains the Dedalic face. Her head is moulded, the lower part of the body was turned on the wheel, the arms and feet were handmade. She is already freer in composition than her Cretan contemporaries and her poignancy is a notable advance in expressiveness. Rhodes in particular and East Greece in general (the settlements along the coast of Asia Minor) now became the innovators of the hollow-moulded figure which was to transform the trickle of terracotta production into a flood.

These hollow-moulded terracottas were made at the end of the sixth century and were, as with so many innovations, something of an accident. 'Plastic vases' or perfume bottles were popular containers of scents and oils and were prized as much for themselves as for their contents. They were made in a variety of subjects and the repertoire included sirens, crouching dwarfs and the goddess Aphrodite (18, 19) who is holding a dove in her left hand. She has the archaic smile. This subject was also reproduced as a figure in its own right and in plate 20 we see the identical Aphrodite, hollow like a vase but with the rim missing. Both types were moulded in two halves, back and front, and

32

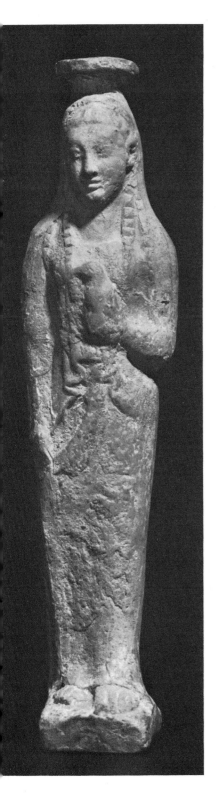

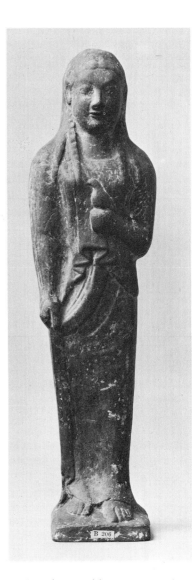

20 Standing goddess. East Greek, mid sixth century BC. Height 25.5 cm.

18, 19 Standing goddess (perfume bottle). East Greek, mid sixth century BC. Height 19 cm.

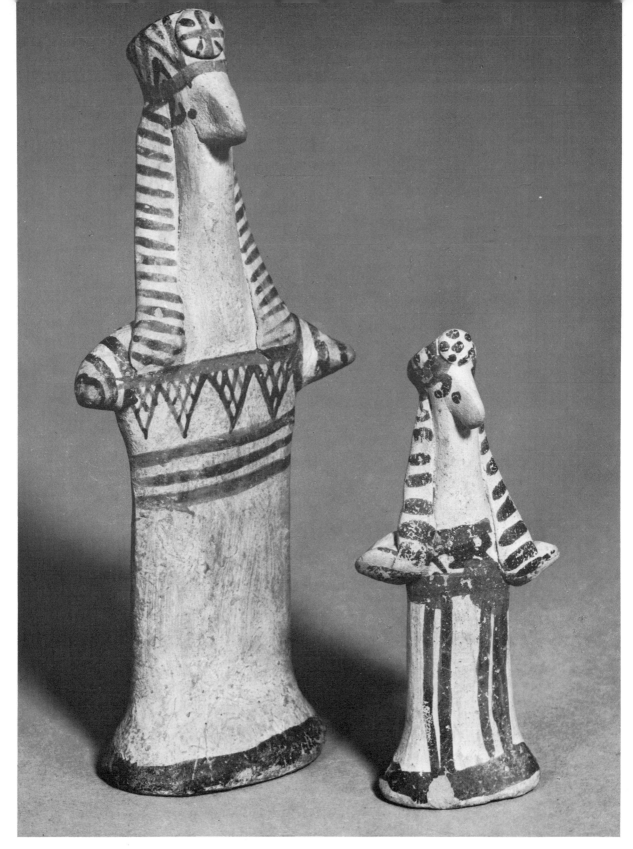

22 Two standing goddesses. Boeotian, early sixth century BC. Heights 16, 9.5 cm.

this speeded the manufacture of terracottas which, from now onwards, were produced by this mass-production method. For a half century or more, figures and vases were virtually interchangeable in design, and the seated woman (21) had her counterpart in a perfume bottle. The vases had their vent through the rim, the related statues had a hole in the base to allow the air to escape in firing.

Boeotia

The small region of Greece to the north of Athens, known as Boeotia with Tanagra as its main centre, often led the rest of the Greek world in new styles and techniques as well as in artistic perfection. Following the Geometric bell-idols, and no doubt developing from them, came Boeotia's next advance – solid handmade figures that had 'glazed' stripes in a rich abundance of decoration. The standing goddesses (22), horse and rider (23) and squatting monkey (24) all have these stripes which are fired and have therefore resisted the wear and tear of time. The colours are as fresh as on 'glazed' vases of the time, black when successfully fired and orange or brown when mis-fired. The goddess

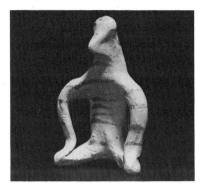

24★ Squatting Monkey. Boeotian, mid sixth century BC. Height 7.5 cm.

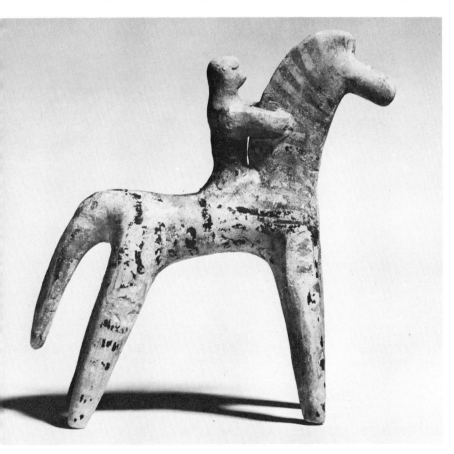

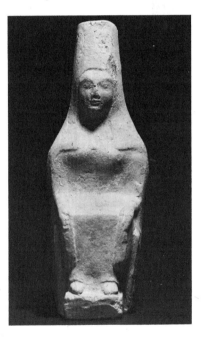

21 Seated goddess. East Greek, late sixth century BC. Height 15 cm.

23 Horse and rider. Boeotian, mid sixth century BC. Height 13 cm.

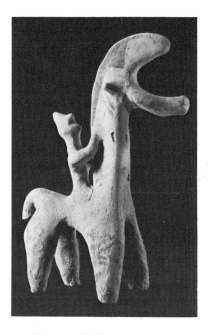

26 Horse and rider. Cypriot, seventh century BC. Height 22.5 cm.

is the commonest type, occasionally with a woman's face but more often she is bird-like with a marked affinity to the Mycenaean goddesses of six hundred or so years before. The similarity is obviously not a coincidence. The horse and rider is another common theme, very stylized, and the monkey with its pinched-out face strongly echoes the goddesses. The economy of style of these early figures is curiously modern to our eyes.

The colours on later Boeotian figures were painted matt after being fired. They are therefore fugitive and we are down to the bare clay. These figures are also stylized to a marked degree and the chariot group (25) is suggested rather than elaborated.

Cyprus

The very fine Cypriot horse and rider from the Boston museum (26) carries stylization even further than its Boeotian counterpart, and is even more satisfying aesthetically. The nose and mane of the animal are sculpted in dramatic curves. Greek influence on Cyprus was paramount from the sixth century onwards, and the three little heads (27) all have the archaic features typical of the mainland. The warrior with scaled helmet is hollow-moulded whereas the other two heads are solid.

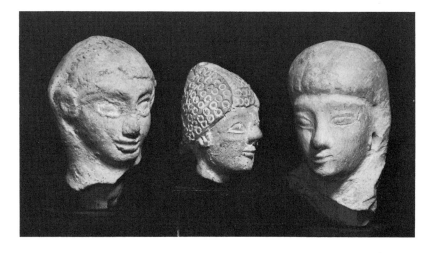

27 Three heads. Cypriot, sixth century BC. Heights 5.5, 4, 6 cm.

25★ Chariot group. Boeotian, sixth century BC. Height 10.5 cm.

36

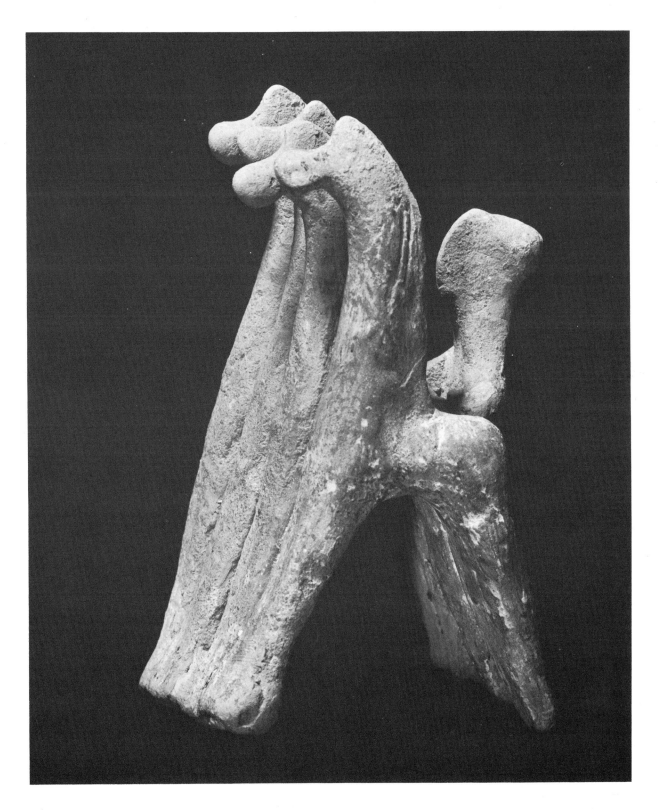

4 CLASSICAL c.500‑330BC

The Persian invasions of Greece that ended in 479 BC contributed to the end of the Archaic and the beginning of the Classical periods. The Greeks had been victorious and the new sculpture and architecture that developed were stronger and more confident, as befitted men who had trounced their enemies and founded the Athenian Empire in 478 BC. A new spirit pervades Greek art. It is freer in movement, more secular, with the blemishes of life given greater prominence, and we shall see this change reflected in the terracottas that come into this period. The transition from Archaic idealism and serenity to Classical realism is gradual and spans two hundred years.

Rhodes

From now on terracottas were almost always produced by the moulded method, sometimes solid but more usually hollow. The Eastern Greeks had led the way in moulding in the sixth century and, for another hundred years or so, Rhodes was to be an important centre, tailing off in the fourth century with a corresponding rise in other regions.

Our first plate from Rhodes (28) shows a 'protome', which is really a miniature bust showing the upper half of a human figure (usually female), pierced for suspension and lacking a separate back. She still has an archaic smile and may represent Hera. Protomes were popular domestic statuettes for two centuries and were made in many Greek centres.

The little animals (29) are rather crude and, as with so much Rhodian production, these were copied and improved upon in mainland Greece. The tortoise and pig are hollow and sometimes purposely contain a stone so that the figure doubles as a child's rattle. The boy riding a turtle is solid, the reptile is moulded and the boy handmade and added as a delightful and amusing afterthought.

Boeotia

As before and as will occur again and again, Boeotia takes the ideas emanating from Rhodes and other centres and both embellishes and perfects these styles into her own brand of excellence. Throughout the history of terracottas, Boeotian frequently means the best. Her coroplasts were more influenced by the great sculptors of marble and bronze than in other regions and, particularly from the fourth century on‑

28 Female protome. Rhodian, *c.* 500 BC. Height 12 cm.

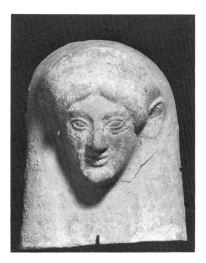

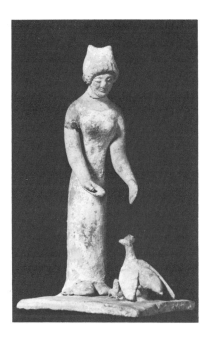

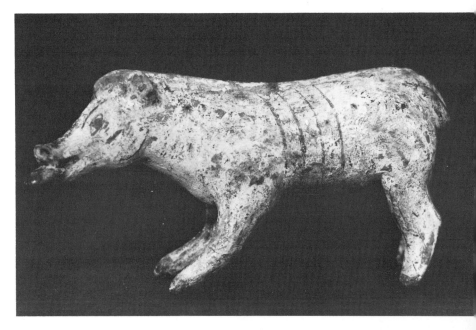

31 Woman feeding hens and chicks. Boeotian, early fifth century BC. Height 12.5 cm.

30 Boar with cake in mouth. Boeotian, early fifth century BC. Height 5 cm.

32 Dog with cake in mouth and bird on back. Boeotian, early fifth century BC. Height 7.5 cm.

33 Woman cooking. Boeotian, c. 500 BC. Height 10 cm.

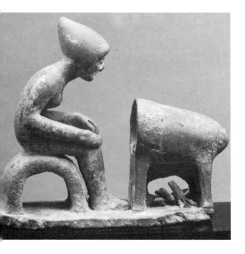

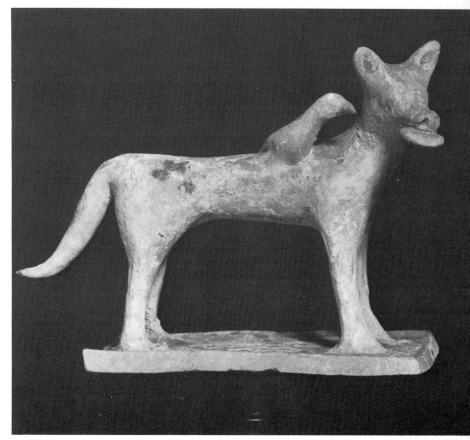

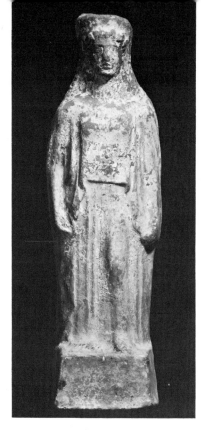

wards, their diminutive counterparts quite frequently echo larger statues. Boeotian terracottas of all centuries, culminating in the famous Tanagras in the next chapter, have a dignity, flair and wit that often exceed those from other centres.

The animal and *genre* pieces (scenes from everyday life) in the first half of the fifth century are a case in point. These (30–33) were made about the same time as their Rhodian equivalents (29), yet are more developed schematically and have infinitely more feeling for the subject. The housewives feeding their hens (31) and cooking (33) make us chuckle at the familiar scenes but they are satisfying also as works of art. The wild boar with a cake in its mouth (30) presumably represents an episode of successful marauding, and the dog (32) with a bird on its back, showing interest in a cake in the dog's mouth, is a nice conceit.

The boar (30) is highly coloured with red stripes on his back and round the eyes and yellow along the mane and back to the end of his curly tail. A white 'slip' lies under the colours. It will be remembered from the introduction that this 'slip' is a film of dilute clay that covered the figure and was fired, thus providing a white canvas for the matt colours that were added after the figure was withdrawn from the kiln, colours that are therefore fugitive. This method of colouring terracottas spread to all centres in the Classical period.

Standing figures in Boeotia also showed an advance over their contemporaries in Rhodes and elsewhere. The woman (34) is of the mid-fifth century. She is wearing a peplos with a long overfall, her waved hair is down to the shoulders, and she wears a low polos (originally with projection behind, now broken). The near-naked youths (35, 36) are of the same period and stand, very much at their ease, holding a

34 Standing woman. Boeotian, mid fifth century BC. Height 23 cm.

29 Pig, boy on turtle, tortoise. Rhodian, fifth century BC. Heights 5, 4.5, 3.5 cm.

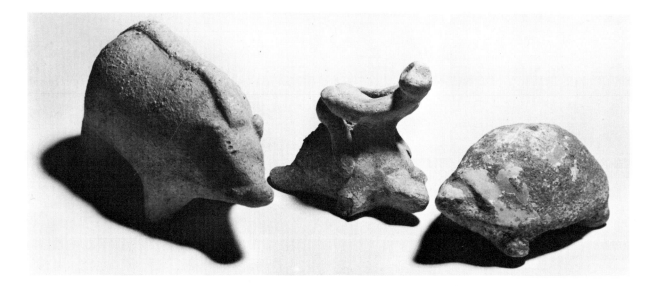

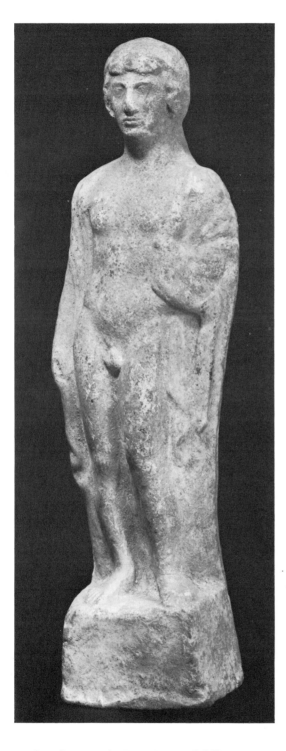 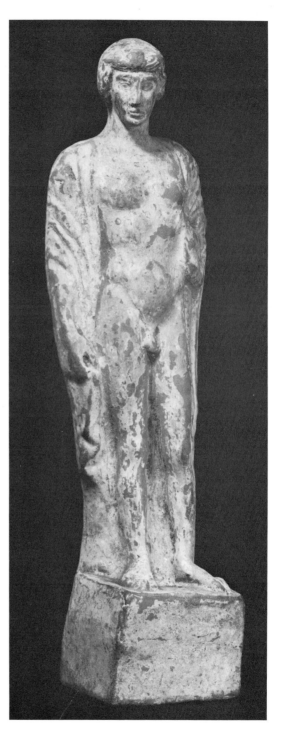

35 Standing youth. Boeotian, mid fifth century BC. Height 26 cm.

36★ Standing youth. Boeotian, mid fifth century BC. Height 26 cm.

37 Banqueter. Attic, early
fifth century BC. Height 6.5 cm.

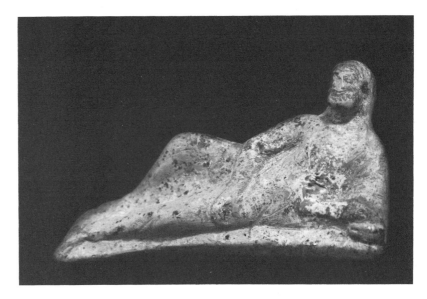

38 Reclining woman. Attic,
early fifth century BC. Height
15.5 cm.

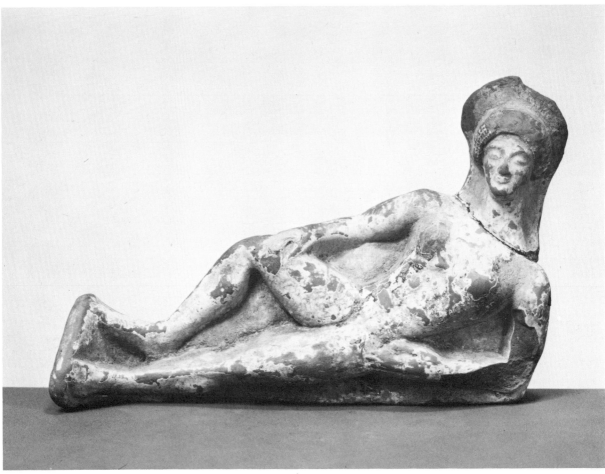

cockerel in their left hands. It is not known whether they represent a deity, a hero or just a young man. They wear long himations and have a lot of pink decoration on the body over the white slip. Their stance is realistically portrayed with the weight thrown convincingly on to the right foot, yet with the left foot forward and therefore reminiscent of the Archaic *kouroi*; they usher in the fourth century with its more realistic moulding of the human anatomy. All three Boeotian standing figures are only frontally moulded with very large rectangular vent holes at the back and they are open at the base. The clay is thinner than in earlier figures, as moulding techniques improved. The colour plate emphasizes the white slip on the Boeotian youth.

Attica

Athens becomes increasingly important from now onwards. Attic styles included terracottas that were altogether more entertaining and secular as religion was eased into the background. The banqueter (37) and reclining woman (38), possibly a *hetaera* or courtesan, are also of the fifth century, but are a far cry from their more reticent Boeotian and Corinthian contemporaries. The banqueter reclines on a legless couch with a cup in his left hand, his smile is that of repletion rather than archaic serenity, and is echoed by that of the woman. Athens certainly produced more sober figures as well; a seated goddess of great decorum was a common subject much copied and exported, and, in the same fifth century, we find standing men and women similar to those produced in Rhodes and Boeotia at this time. But levity in the capital city of Athens increased in the fourth century and we now come upon a new group, of actors, which is indeed a break with the past.

These comic actors (39) are of the mid-fourth century. The seated figure represents a traveller (typified by his conical cap), and his left hand is under his chin in an attitude of exhaustion. The standing figure wears a grotesque mask and padded phallic costume. Sets of actors in various guises and subjects were made—the Metropolitan Museum in New York has two such sets—and plate 40 shows a similar figure from the Fitzwilliam Museum in Cambridge. They are bizarre representations that may surprise us by their realism, a far cry indeed from the spiritual goddesses of a hundred years earlier.

Corinth

Corinth as a centre was distinguished by the fineness of its clay which enabled terracottas to be modelled in great detail. The two figures (41) are of Demeter, the Greek goddess of the corn-bearing earth and agriculture. She holds a flower in both instances. Each figure is late Archaic in style and dates from *c*. 500 BC, they are front-moulded, hollow and open at the back.

40 Comic actor. Attic (?), mid fourth century BC. Height 11 cm.

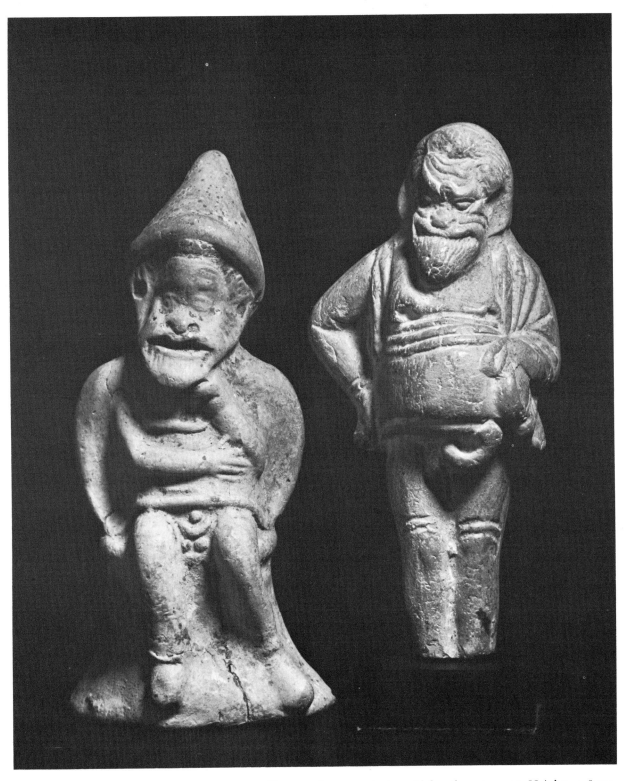

39 Two comic actors. Attic, mid fourth century BC. Heights 9, 8 cm.

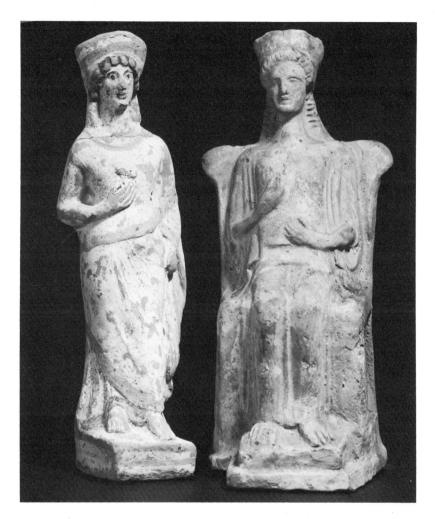

41 Standing and seated figures of Demeter. Corinthian, *c.* 500 BC. Heights 17.5, 17.5 cm.

42 Articulated doll. Corinthian, early fifth century BC. Height 13.5 cm.

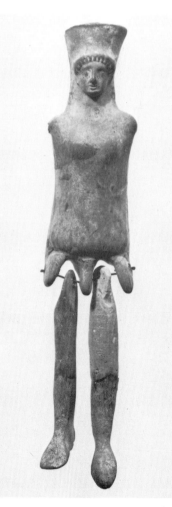

I found the standing figure of Demeter in a shop in Paris where I have bought things from time to time, encrusted with dirt and features blurred, a piece I suspected was Corinthian but obviously excavated long ago with the accretion of years covering its true identity. In the sensitive hands of a restorer, the dirt was carefully washed away so that the matt colours underneath were not damaged and Demeter stands revealed in all her pristine glory with mainly purple and red standing out sharply over the white slip (see colour plate).

Solid moulded figures continued to be made in Corinth for a longer period than elsewhere, often with considerable skill, and articulated dolls were a speciality. The armless version in the Fitzwilliam Museum in Cambridge (42) has swinging legs and a hole in the top of the head for suspension so that the doll can be made to dance like a modern puppet. Some dolls were clothed, others were naked and were probably intended to be dressed up by children.

45

South Italy

Italian sculpture in all its forms is a fascinating study apart and, in early South Italian terracottas, the same influences are felt as in larger statues: local, Greek, and Etruscan. The principal sites in the fifth and fourth centuries were Locri, Paestum and, above all, Tarentum (Taranto in modern Italy) which was the most prolific centre of all. In one find spot alone 30,000 votive terracottas were discovered. Tarentine figures are notable for their pale orange colour and fine texture. Dionysus, 'god of wine who loosens care and inspires to music and poetry', was common both bearded (43) and clean shaven, and is usually shown with a lotus flower in his hair. The complete figure usually reclines on a couch with a drinking cup or libation vessel known as a phiale in his left hand. An early Tarentine mask (44) of *c.* 500 BC is probably also of Dionysus. I believe the original mould was Boeotian, in view of its quality, but the figure was made in Tarentum from local clay which is pale orange. Interesting precedents for this view exist in the Louvre where similar masks can be seen (Nos. B.98 and B.520).

We know little of the Etruscans, even now their language remains unread, but they were a considerable political force until *c.* 500 BC and had a strong artistic influence that lasted until Hellenistic times. The pair of shoes, *calcei repandi,* (45) are probably perfume bottles as they are hollow and finished at the top, not broken off as I had first thought and therefore not the feet of a larger statue. Or they may have been funerary accompaniments for the long walk to the next world – the American School of Classical Studies excavated a Greek pair of shoes in the Agora of Athens in pristine condition that were devoid of oils or

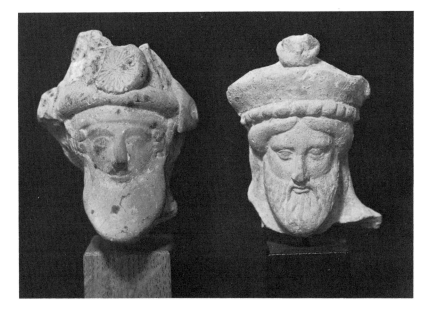

43 Two heads of Dionysus. Tarentine, early fifth century BC. Heights 9, 9 cm.

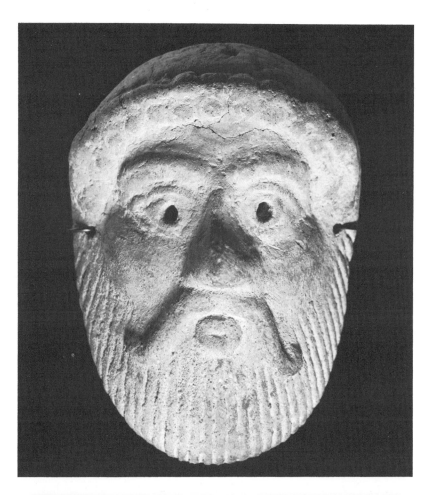

44 Mask. Tarentine (?), *c.* 500 BC. Height 12 cm.

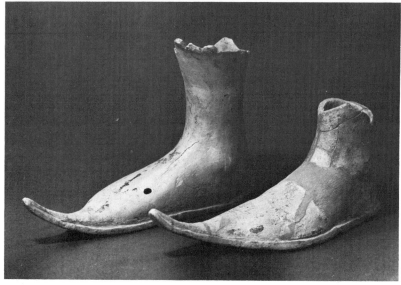

45* A pair of shoes (? perfume bottles). Etruscan, early fifth century BC. Heights 14, 10 cm, lengths 23, 23 cm.

47

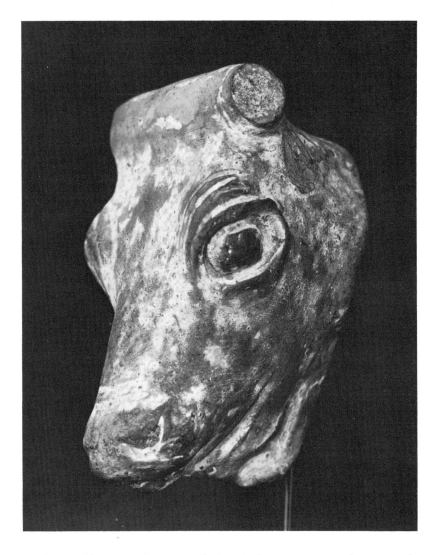

46 Bull's head. South Italian, mid fifth century BC. Height 10.5 cm.

Opposite
Demeter, Greek goddess of the corn-bearing earth and agriculture, Corinth, c. 500 BC.

Page 50
Youth, Boeotia, c. mid 5th century BC.

Page 51
Goddesses, Mycenae, c. 1425–1200 BC.

perfumes. Etruscan frescoes of the sixth century BC show stately courtiers wearing similar shoes and these terracotta copies probably date from then. Mine were purchased from an old collector-dealer in Florence, as was also the bull's head with horns and ears missing (46). This is of the fifth century BC, of red-brown clay and, like the feet, was found in South Italy.

Campanian reliefs are an interesting minor *oeuvre* of the fifth century. Known as 'appliqués', they were flat-backed and probably stuck as ornaments on to furniture or coffins. The satyr (47) is a powerful work considering his diminutive size of 1½″ (4 cm). The satiric scorn comes over strongly and I like his bulbous nose and etched contours. There is one almost exactly similar in the British Museum. Other subjects in Campanian reliefs include gorgons and masks of satyrs.

48

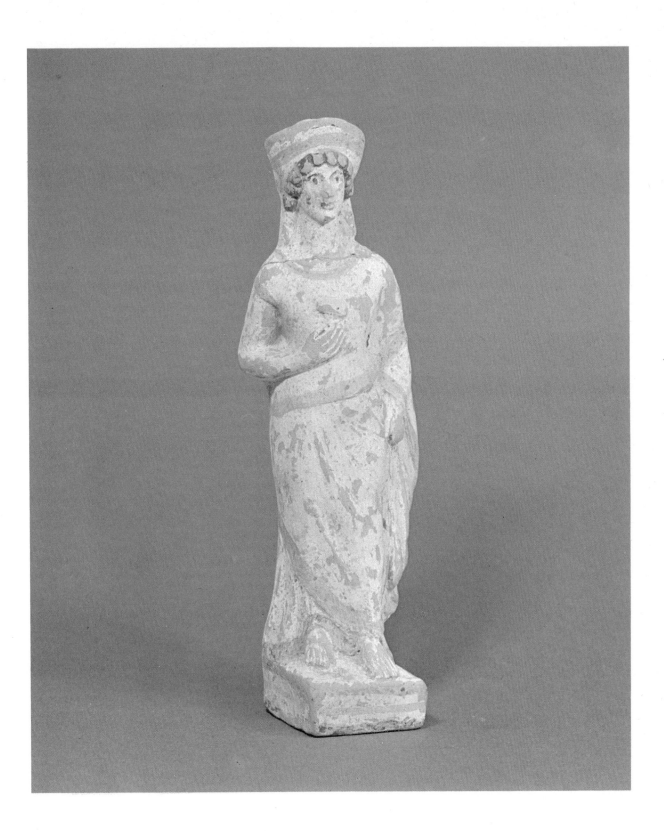

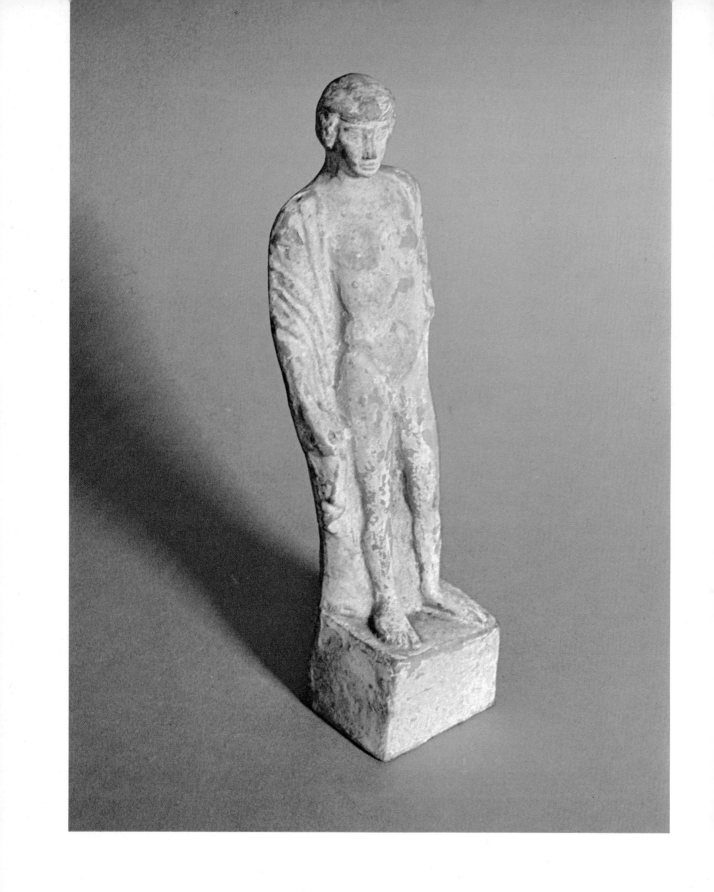

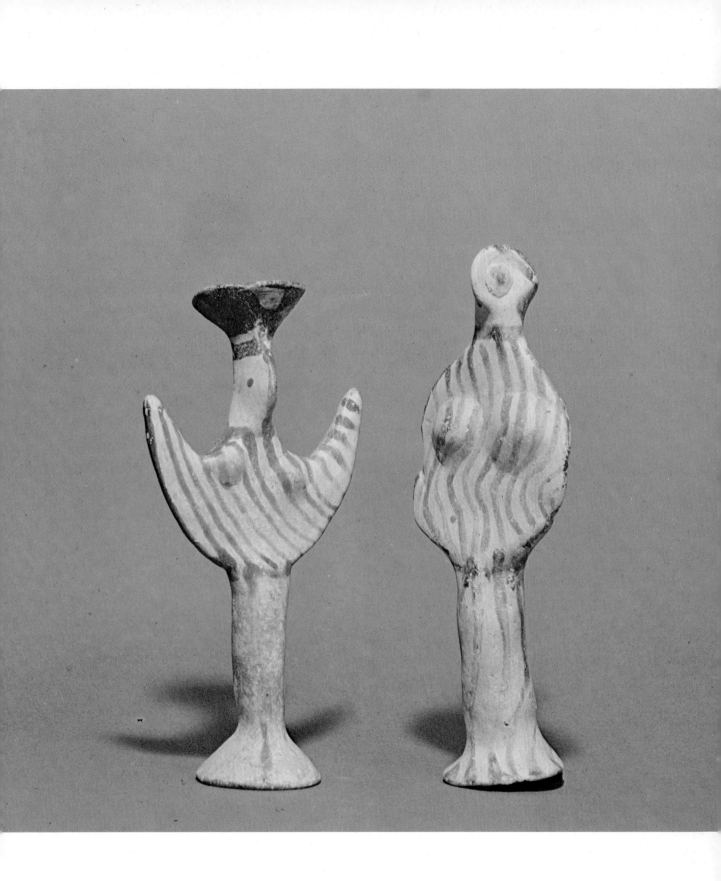

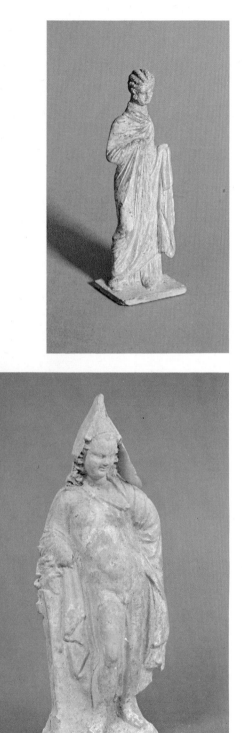
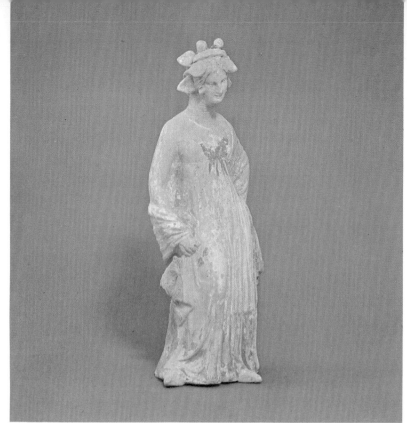
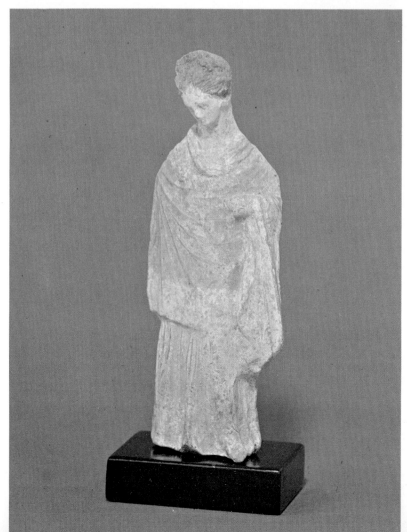

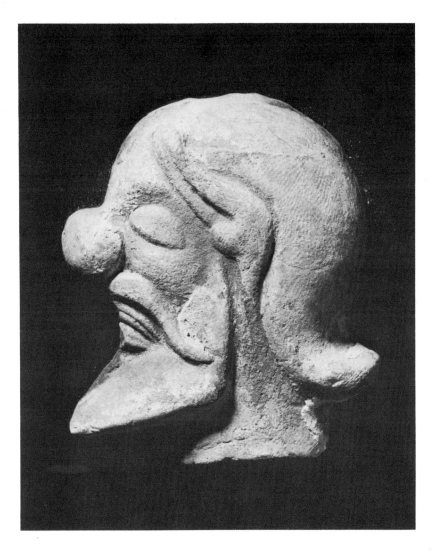

47 Relief of satyr. Campanian, fifth century BC. Height 4 cm.

Sicily

The Greeks colonized Sicily in the eighth and seventh centuries BC and the island was, of course, much influenced by Italy, yet it produced a remarkable unity of style that was often distinctive from the mainland. We find Sicilian terracottas as early as the seventh century and large quantities were produced there until Hellenistic times. A typical subject is an unknown seated goddess (48) who is wearing a tall polos, often with peplos fastened at the shoulders with large brooches and pectoral ornaments across her breast. Sicilian styles were also affected by Rhodes whence she imported terracottas before her own industry began and, in the protomes (49) and woman and child (50), archaic Rhodian influences are discernible and the archaic smile.

The composition of the woman and child is a Sicilian solution how-

Standing woman, Tanagra, c. 330–200 BC.

Top right
Standing woman, South Italy, 3rd century BC.

Bottom left
Eros, South Italy, 3rd century BC.

Bottom right
Standing woman, Alexandria, 3rd century BC.

49★ Two female protomes.
Sicilian, fifth century BC.
Heights 15, 17 cm.

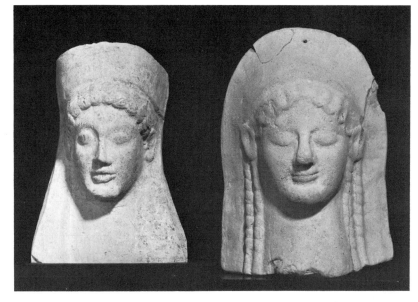

50 Seated woman and child.
Sicilian, early fifth century BC.
Height 9 cm.

48★ Seated woman. Sicilian,
early fifth century BC. Height
20.5 cm.

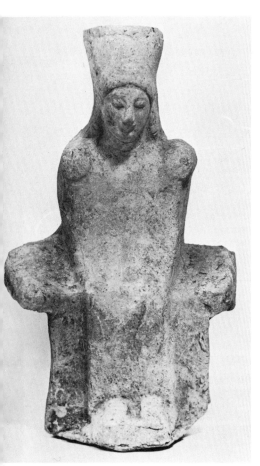

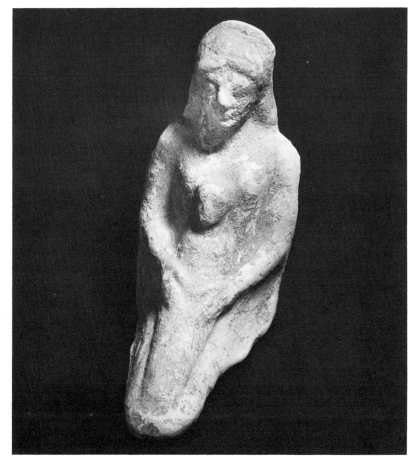

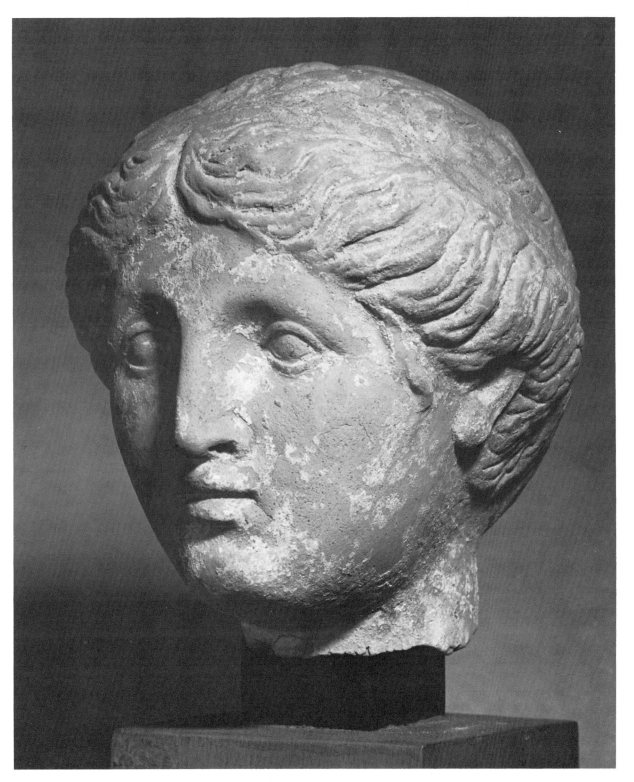

51 Female head. Sicilian, fourth century BC. Height 17.5 cm.

ever, both charming and practical in moulding such a group; the protomes echo that from Rhodes (28), yet have taken a step forward in decoration with hair waved fully round the forehead, and a veritable stride forward in feeling and expressiveness. The large female head (51) is also an advance in sculptural terms and must surely echo a major work in marble or bronze.

Crete

After the Dedalic figures of the seventh century, Crete initiated no styles of her own and tended to copy other centres. Studies are, however, being made of the island's production after the Dedalic period and it is thought that Knossos in particular was responsible for major groups. I have photographed the miniature goddess (52) against a matchbox to show her miniscule size. She was probably excavated at Phaestos. Her definition of detail is poor, but she achieves an amazing reduction in the typical, late archaic forms of the fifth century with chiton and himation clearly shown.

Melos

No study of the Classical era of terracottas is complete without consideration of the speciality of Melos—reliefs, thought to have decorated wooden chests or coffins. These reliefs have been found in other islands of the Cyclades and in Greek settlements, particularly Tarentum, but those from Melos were finer and included a variety of themes popular with contemporary painters of vases. They were flat plaques moulded in front with holes pierced for attachment, gaily painted in their original state and fired at high temperatures to withstand wear and tear. Their themes cover a wide spectrum of Greek mythology and scenes from nature such as that reproduced here, usually somewhat stylized. There is an unsophisticated charm in the example from the Allard Pierson Museum in Amsterdam (53) of a fancifully drawn boar being hunted—somewhat unsuccessfully it appears.

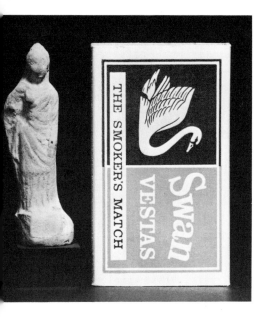

52 Miniature standing goddess. Cretan, late fifth century BC. Height 6.5 cm.

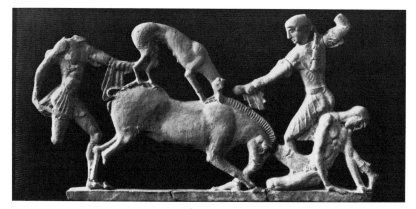

53 Relief. Melian, mid fifth century BC. Height 15 cm.

5 HELLENISTIC c.330 BC-AD 100

Hellenistic is the term applied to the civilization that is already Greek in its general character (Greece itself and the Western Mediterranean) but embracing people in Asia Minor, Egypt, Syria and the other countries subjugated by Alexander the Great between 333–323 BC. This greatest of all generals, educated by Aristotle and dead of a fever at only 32, not only changed the face of the Greek Empire militarily: he also caused the classical ethos in art to alter abruptly. Before Alexander, the Greek dominions were closer at hand, yet retained regional styles of mainly religious inspiration; after his swift conquests the Hellenistic world stretched out and cultural centres were established further afield, particularly at Alexandria. The pen followed the sword and Greek conformity in artistic styles was imposed on these outer lands. Religious inspiration also lessened even further and secular themes tended to take over. The Hellenistic era lasted until the time of Christ but, in classifying terracottas, it is convenient to extend the terminology until *c.* AD 100. Thereafter the Romans prostituted Greek styles—to their considerable detriment.

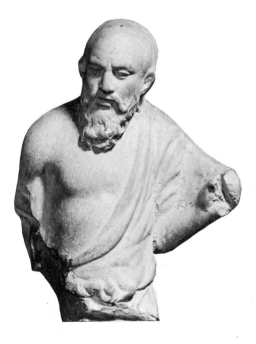

54 Bust of a man. Attic, second century BC. Height 9 cm.

Attica

So our extrovert Attic actors of *c.* 350 BC (39, 40) can be seen as fore-runners of the more secular themes in terracottas that followed from *c.* 330 BC, almost without a break, until indifferent Graeco-Roman copies of Greek deities started to appear around the time of Christ. The bust of a man (54) is clearly a portrait, perhaps of Sophocles and, if so, it is posthumous as the Attic tragedian died in 406 BC. The group of Eros riding two peacocks (55) is religious in theme (peacocks were sacred to Hera) but secular in feeling, with the chariot drawn by the peacocks amusingly suggested by a wheel, and, though admittedly we take a jump in time to the Late Hellenistic period, the comic mask (56) is a forceful clay copy of a stage mask, lifesize.

The charming secular group (57) which is early Hellenistic, probably from Attica though possibly from Corinth or Boeotia, shows two maidens playing the game of *Ephedrismos* in which one player is carried on the back of the other as a forfeit. As can be imagined, this piece is made up of many separate moulded parts stuck together with wet clay before firing. It is the best example of this subject in any public collection, unpublished so far as I know.

57

Athens was seemingly the cradle of the famous Boeotian Tanagra style (see below) which specialized in graceful maidens. Attic 'Tanagras' are tantalizingly rare and differ from their more northern sisters in having no vent holes visible (they were filled after firing), and their clay is orange or red whereas Boeotian clay tends to be brown. Such an Attic figure is the girl (58) with 'melon' coiffure wearing a chiton and with a long overfall girdled under the breasts; a charming young lady of the mid-fourth century and perhaps rather more restrained in style than her naturalistic Boeotian sisters who followed a decade or two later.

Boeotia (Tanagra)

The earliest date established for Hellenistic Tanagra figures is c. 330 BC. One theory which explains the prominence of this little town over Thebes and other Boeotian cities is that the latter were almost destroyed by the Macedonians in 338–335 BC. It was left to Tanagra to continue the tradition in working clay, exporting her terracottas, which were seminal to all other Greek centres, until c. 200 BC.

Tanagras are the flower of all terracottas, inasmuch as they are the most sought after of all periods and styles. The reason is not far to seek. They portray graceful girls or youths of great physical beauty (59-66; and colour plate) standing or sitting in statuesque poses. The repertoire also includes women playing knuckle bones (a popular Hellenistic game), Eros as a chubby infant and, occasionally, grotesques. Their

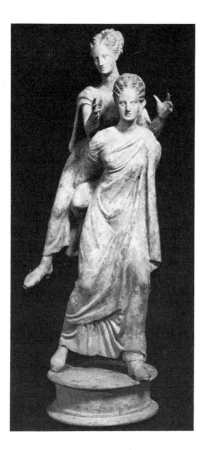

57 "Ephedrismos" group. Attic (?), third century BC. Height 43 cm.

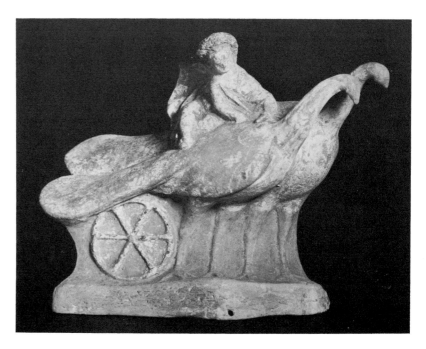

55★ Eros on two peacocks. Attic, third century BC. Height 13 cm.

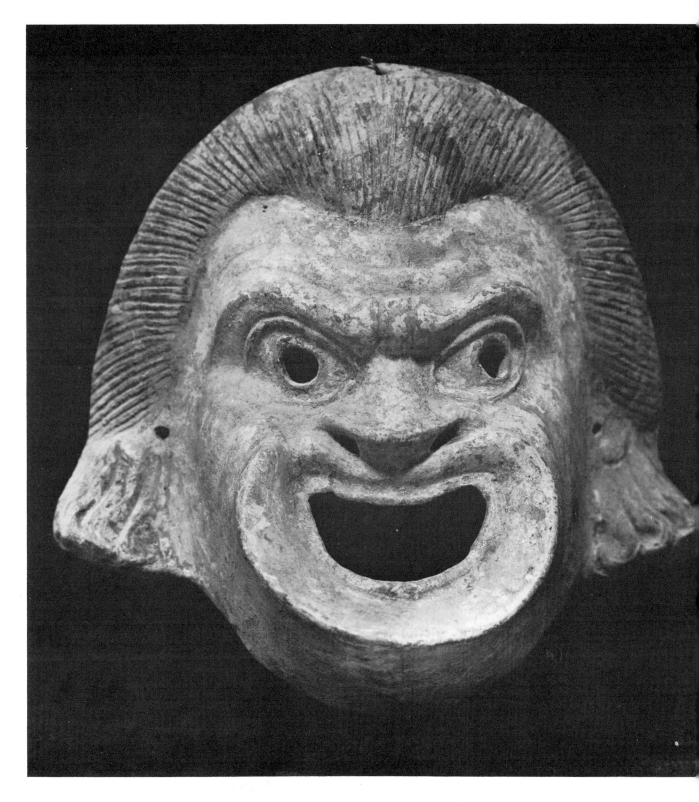

56★ Comic mask. Attic, second century BC. Height 20 cm.

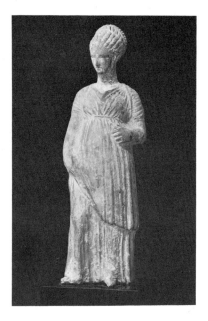

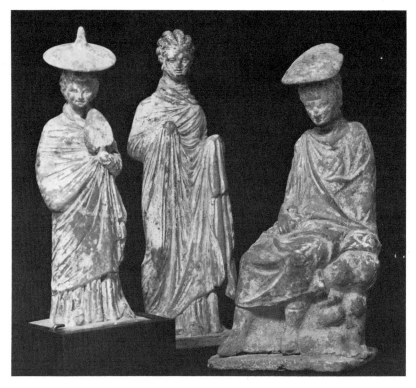

58★ Standing woman. Attic, late fourth century BC. Height 15.5 cm.

59★ Standing boy, standing woman, seated youth. Boeotian (Tanagra), *c.* 330–200 BC. Heights 16.5, 17.5, 17 cm.

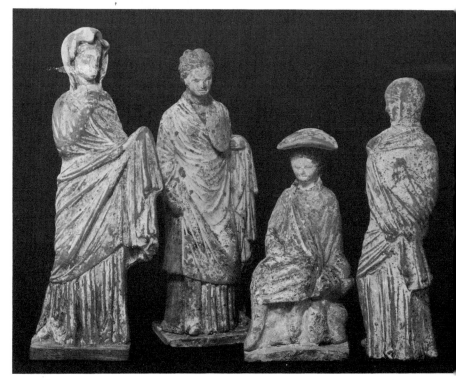

60★ Standing woman, standing woman, seated boy, standing woman. Boeotian (Tanagra), *c.* 330–200 BC. Heights 17, 18, 13, 17 cm.

conception was undoubtedly influenced by Praxiteles who was active in Athens between *c.* 370–330 BC and who had a studio also at Thespiae in Boeotia. Tanagras were modelled with considerable naturalism, the women wearing chitons and himations tightly stretched round the contours of the body, often in opposing directions. If hatless, the girl's hair style was usually the flattering 'melon' coiffure (61), sometimes a himation was drawn up round the mouth as a veil (62), or over the head as a hood (63), and hats were either of the petasos or coolie varieties. These graceful maidens sometimes carried a fan, sometimes an actor's mask which might indicate that she represented a muse, or a mirror denoting Aphrodite; the frontier between religious and secular representation was frequently crossed at this time.

The typical Tanagra figure is made up of a number of different parts, separately moulded and assembled before firing. The more complex the figure (64, 65), the greater the number of parts and these two delightful young women from Girton College[3] show the considerable

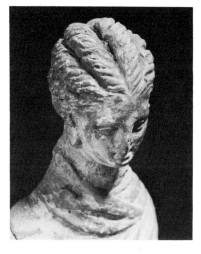

61 Head showing melon coiffure. Boeotian (Tanagra), *c.* 330–200 BC.

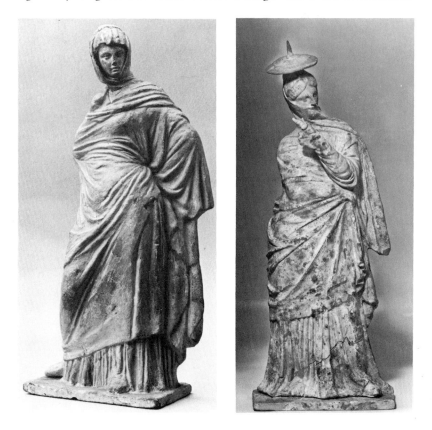

Far left
63 Standing woman, called *La Sophocléenne*. Boeotian (Tanagra), *c.* 330–200 BC. Height 30 cm.

Left
62 Standing woman. Boeotian (Tanagra), *c.* 330–200 BC. Height 30.5 cm.

[3] There are 21 excellent Tanagra figures and other terracottas in a collection at Girton College in Cambridge. They were collected by Lord de Saumarez when he was Secretary to the British Legation in Athens at the end of the nineteenth century and given to the college by his daughter, who was an ex-student, in 1902.

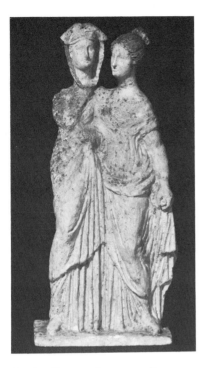

64, 65 Group of two standing
women. Boeotian (Tanagra),
c. 330–200 BC. Height 21.5 cm.

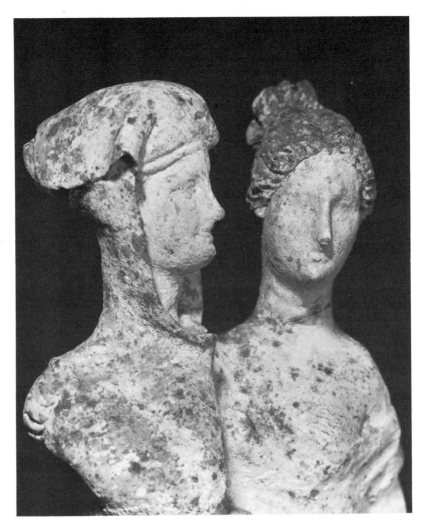

technical strides the art of moulding had made. Appendages, such as
the ball indicated at the side of the athlete (66), were, of course, addi-
tions. Early Hellenistic figures (c. 330–200 BC) were generally only
moulded frontally, the backs being summarily dealt with, but occasion-
ally the backs were carefully worked and figures in the late Hellenistic
period (c. 200 BC–AD 100) particularly can be viewed in the round. The
figures are mostly hollow with vent holes (67) and are placed on a base
for greater stability. They were invariably retouched before firing by
incising dress and hair with a sharp tool to heighten the illusion of tex-
ture and mass. Tanagra, as a centre, ceased to produce c. 200 BC though
the style was to continue less successfully elsewhere for another two
hundred years or more.

I said in the introduction that 'Tanagra' has become a generic term
for all terracotta figures irrespective of their period and provenance. I

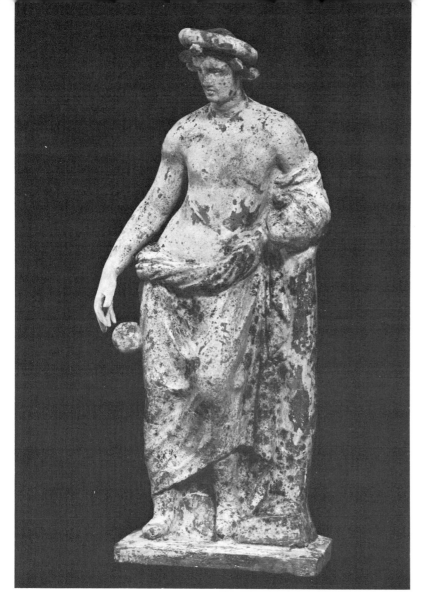

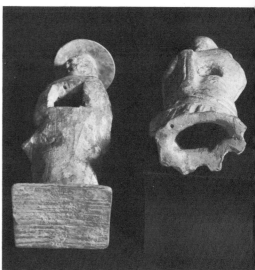

66★ Athlete. Boeotian (Tanagra), c. 330–200 BC. Height 28 cm.

67★ Vent holes, bases and holes for T.L. tests.

hope this is now seen to be misleading, to say the least.

Alexandria

Alexandria was founded by Alexander the Great in 331 BC after his conquest of Egypt. Greeks and Macedonians flocked in to make it a prosperous city which attracted artists including coroplasts of the highest order. Early Hellenistic terracottas between c. 330–200 BC were greatly influenced by the Tanagra style but, of course, used the local clay (known as Nile mud) which was coarse, heavy and red-brown in colour. This clay often retains its slip and colours better than that from other centres and excavated terracottas have preserved these astonishingly well, helped also by the aridity of the soil.

The two standing women (68, 69) were personally excavated in 1921 at Hadra, a suburb of Alexandria, by a man who passed them on to me

63

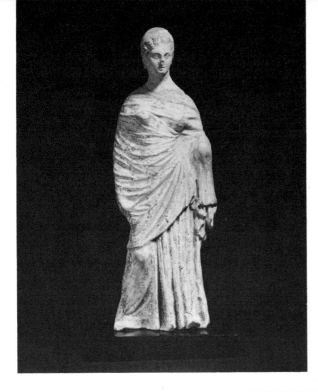

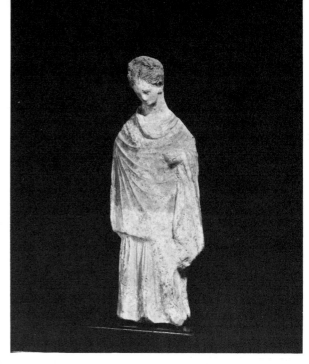

Above
68★ Standing woman.
Alexandrian, third century BC.
Height 30 cm.

Above right
69 Standing woman.
Alexandrian, third century BC.
Height 15 cm.

70 Seated woman. Alexandrian,
third century BC. Height 15 cm.

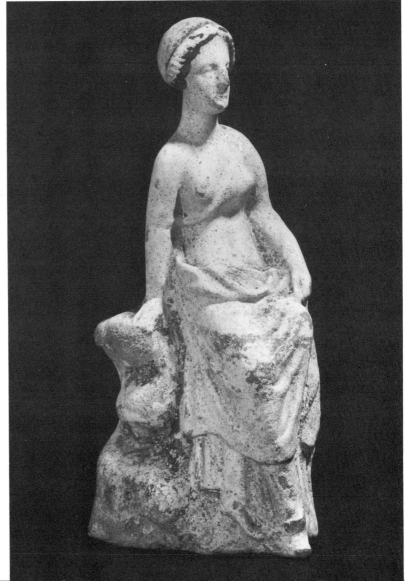

in 1965; despite the fifty or so years that they have been exposed to the air, their colours are still remarkably fresh though, as with all terra-cottas, fading slightly all the time. The two women wear blue chitons, there is yellow on their ear rings and pink tints on their cheeks and hair (see colour plate). The smaller of the two figures is demure and petite, whereas her taller sister is somewhat robust and stately. They both follow the Tanagra style but are marginally less successful, particularly in their detail. The young woman seated on some rocks (70) also follows the style but is stiff when compared with contemporary Tanagras of the third century. She is interesting because of her well-preserved milk-white slip and deep red tints on her hair.

Three other plates complete our section from Alexandria. They are all of red-brown clay, Hellenistic in feeling but less effective than similar Attic examples. Compare the figure of the seated actor (71) with the portrait (54) and the Alexandrian mask (72) with that from Attica (56).

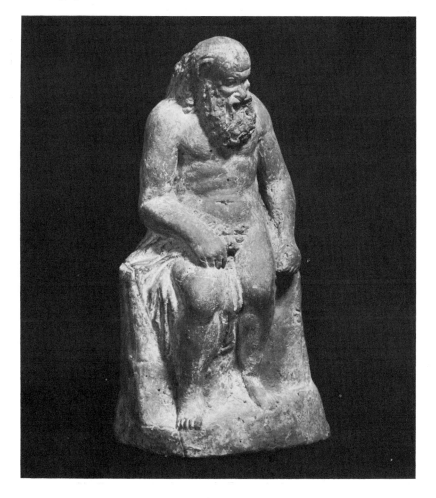

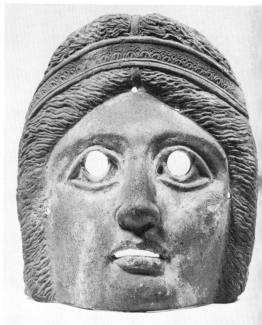

72 Comic mask. Alexandrian, first century BC. Height 18 cm.

71 Seated actor. Alexandrian, third century BC. Height 14.5 cm.

In the late Hellenistic era, from *c.* 200 BC onwards, Graeco-Egyptian themes appeared as the original Greek settlers intermarried and were influenced by Egyptian religious types. We also find grotesques which may be the forerunners of those from Smyrna in Asia Minor (see below).

South Italy

South Italian terracottas, Tarentine in particular, usually have a certain bravura in their conception and seem to wish to break away from the somewhat rigid Tanagra poses. To borrow a musical description, we might say they are *con brio* and I feel the seated lady (73) with kithara (an instrument that was the precursor of the lute) would have performed with the utmost vivacity. The chiton drawn down in a deep 'V' over the knee is a subtle departure in dress style in the standing woman (74); and the tall slender girl with left foot well forward (75) is bolder in

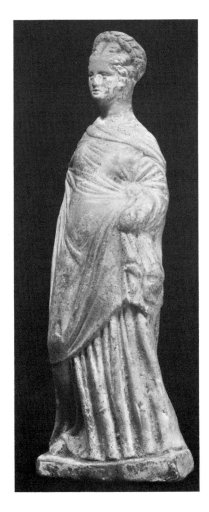
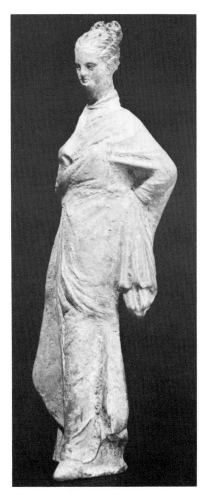

Far right
75 Standing woman. South Italian, third century BC. Height 21.5 cm.

Right
74★ Standing woman. South Italian, *c.* 330–200 BC. Height 22.5 cm.

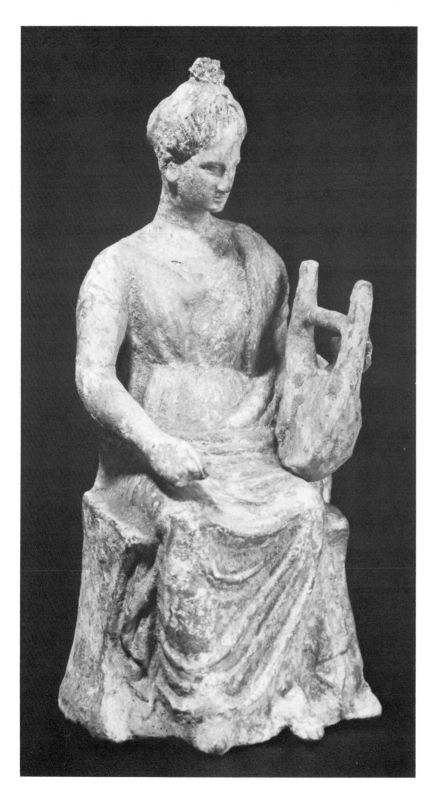

73★ Seated woman with kithara.
South Italian, *c.* 330–200 BC.
Height 19 cm.

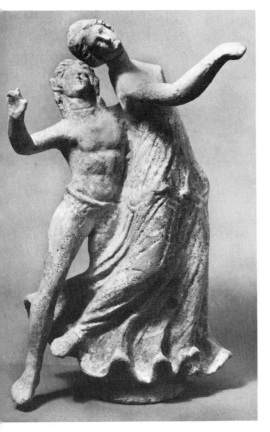

76 Satyr and maenad. Sicilian, *c.* 150 BC. Height 29 cm.

posture than a mainland Greek maiden, yet retains the elegant 'melon' coiffure with looped top-knot. And in the satyr dancing with a maenad (76) from Centuripae in Sicily, *c.* 150 BC and so admittedly later than these early signorinas, we have *con molto brio* in a group which shimmers with movement and grace. The head (possibly the young Herakles) in plate 77 is later still, *c.* 100 BC.

Two figures, of Eros (78; and colour plate) and of a standing woman with vine leaves in her hair (79; and colour plate), show the charm of these third century Tarentine types. The Eros has unfortunately lost his wings but he is a cheerful little fellow who looks quite able to 'put a girdle round about the earth in forty minutes'. He is leaning on a herm surmounted with a mask of Dionysus. He was up for sale in Sotheby's many years ago but I foolishly bid too low and missed him. Recently we met up again at a dealer's in Switzerland, alas at a far higher price, but this time I dug deep into my pocket and bought him.

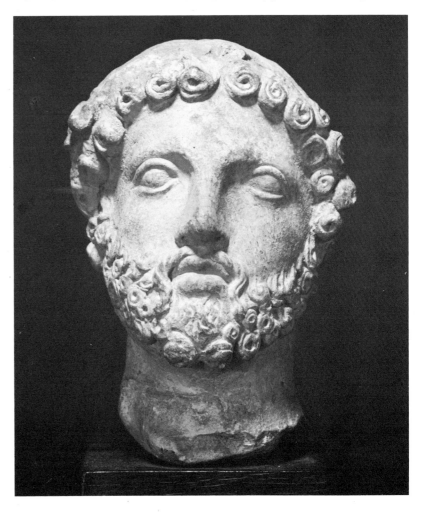

77 Male head. South Italian, *c.* 100 BC. Height 15 cm.

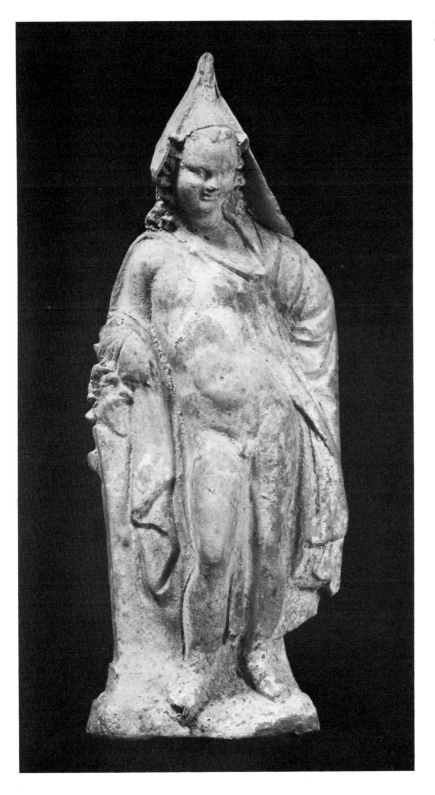

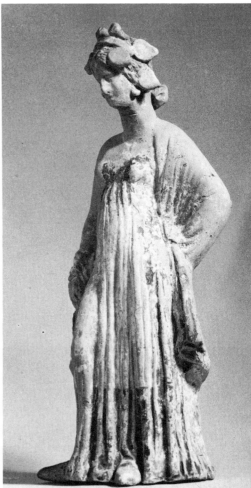

78★ Eros. Tarentine, third century BC. Height 18.5 cm.

79 Standing woman. Tarentine, third century BC. Height 21 cm.

80 Profile head of youth.
Etruscan, third century BC.
Height 23.5 cm.

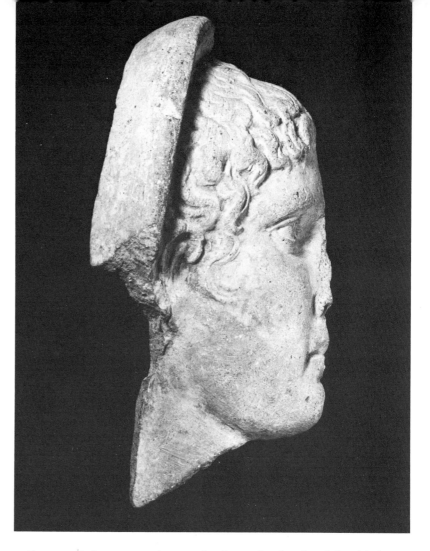

81 Female head. Etruscan, third
century BC. Height 21.5 cm.

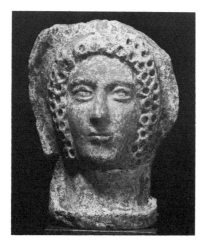

Etruscan influence can be seen in the votive heads of the third cen-
tury, both of which are typically large. The profile of a youth (80) is
of light grey clay, front moulded and hollow behind. The head of a
girl (81) is of brown clay, her face is framed with hair and she wears a
himation over her head.

Myrina

Myrina, the region to the north of Smyrna in Asia Minor, took over
the lead in terracottas from Tanagra *c.* 200 BC. Tanagra was to early
Hellenistic what Myrina was to late Hellenistic and both were supreme
in their different periods and styles. The earlier restrained Tanagras
gave way to the more lively and elaborate figures that flourished in
Myrina until the time of Christ. Any student of terracottas wishing to
see Myrina figures *en masse*, should go to the Louvre in Paris where he
will see displayed the large collection excavated in the 1880s by Reinach
and Pottier of the French School in Athens.

The little Eros (82; and jacket) shows this greater freedom of move-

70

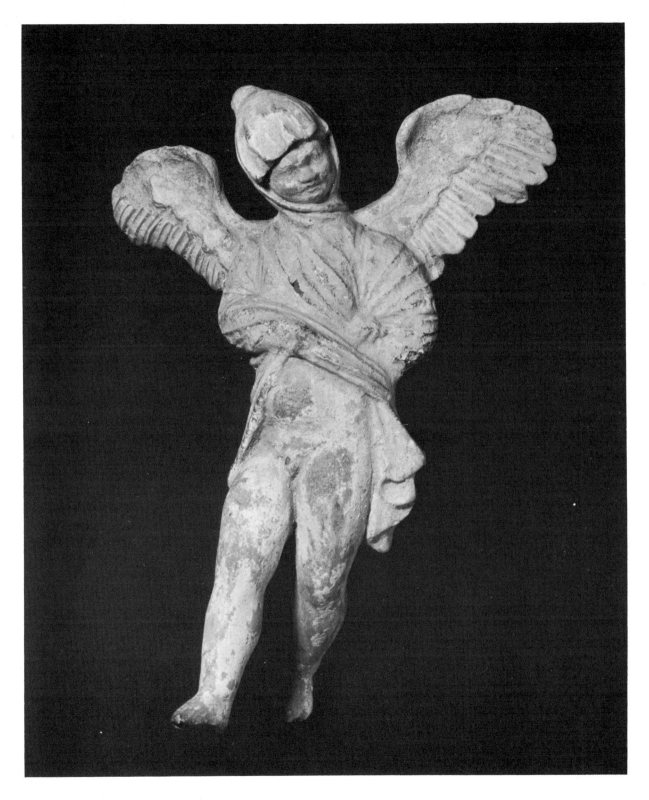

82★ Eros. Myrinan, second century BC. Height 14 cm.

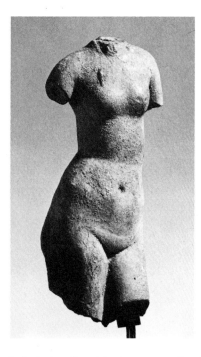

84★ Aphrodite. Myrinan, second
century BC. Height 15 cm.

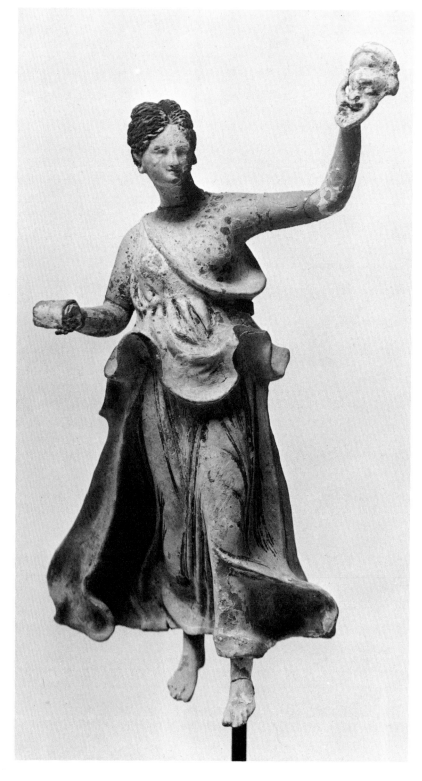

83 Nike, with mask. Myrinan,
second century BC. Height
26.5 cm.

ment as does the Nike, goddess of Victory (83), who is holding a mask in her left hand as she swoops down to earth. The fragment of Aphrodite (84) is delightfully sinuous and the complete figure would have shown the goddess removing her sandal (a common subject). Aphrodite in the form of a child's doll (85) is interesting because it is, and was intended to be, armless–no doubt to facilitate quicker dressing-up. The pinnacle of Myrinan art may be seen in the Crouching Aphrodite (86) from the Paul Getty Museum in Malibu, California, which must have been inspired by a third century marble original of Aphrodite washing herself. What a charming figure this is! The visitor to the Louvre collection should also seek out their catalogue No. 375, which is of a similar Aphrodite kneeling on the ground. Our last example from Myrina is a mask of a youth (87), surely a copy of an actor's full size mask. Such miniatures are thought to have been hung up at Dionysiac festivals.

Vast quantities of terracottas were unearthed in the cemeteries of Myrina. They were frequently signed on the backs and one coroplast, Diphilos, apparently started a firm since pieces bearing his name continued for a century or more.

Smyrna

Smyrna was the other great centre for terracottas in the late Hellenistic period, best known perhaps for its grotesque heads. Reynold Higgins in his definitive study, *Greek Terracottas* (London, 1967), suggests that heads from Smyrna predominate over complete figures in private and public collections because nineteenth century tomb robbers found these to be more profitable than torsos. They filled their sacks with heads which they broke off from the complete figures and made a dash for it. Our two plates show the head of a slave (88) and two grotesques (89). They all vibrate with malice.

Complete figures from other parts of Asia Minor are common enough, often of excellent inspiration but tending to be somewhat flamboyant. It is often difficult to pinpoint their definite provenance, as in the case of the negro boy slave clasping an outsize amphora (90).

To end the chapter on Hellenistic terracottas I thought it would be amusing to include a gallery of small heads. They are a mixed lot from all regions of the third and second centuries BC and they are grouped under Beauties (91) and Beasts (92). An enlargement of a small head (93) whose actual height is only $1\frac{1}{4}''$ (3.5 cm), offers convincing proof of the bewitching charm that can be contained in these tiny figures.

85 Doll. Myrinan, second century BC. Height 16.5 cm.

86 Crouching Aphrodite. Myrinan, second century BC. Height 22 cm.

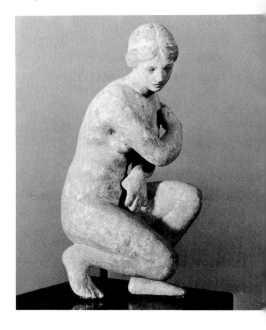

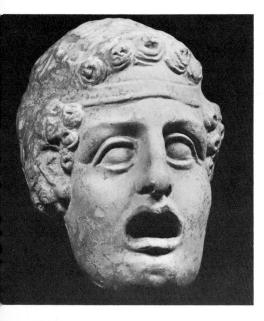

88 Grotesque head, Smyrnan,
second century BC. Height 6.5 cm.

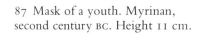

87 Mask of a youth. Myrinan,
second century BC. Height 11 cm.

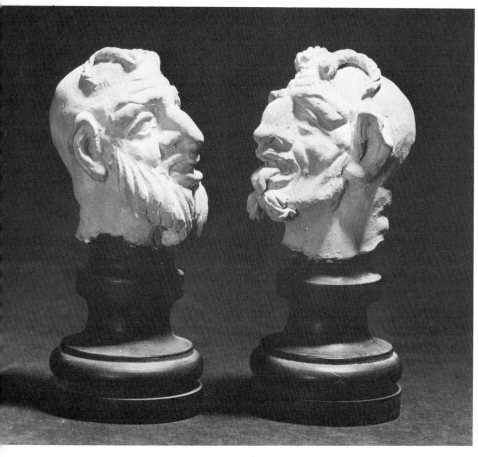

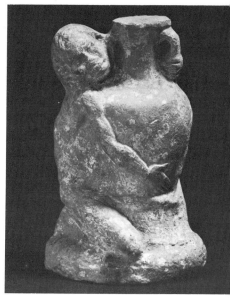

90 Negro boy clasping amphora.
Asia Minor, second century BC.
Height 8 cm.

89 Two grotesque heads.
Smyrnan, second century BC.
Height 7 cm.

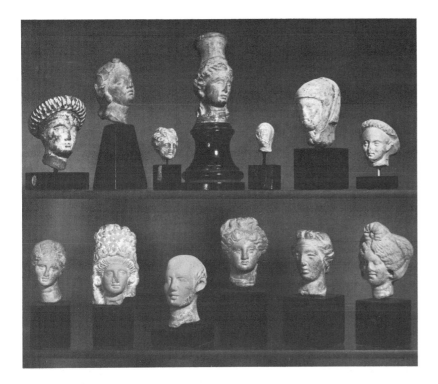

91 Group of heads. Hellenistic, third to second centuries BC.

92 Group of heads. Hellenistic, third to second centuries BC.

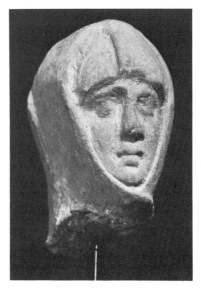

93 Female head. Hellenistic, third century BC. Height 3.5 cm.

6 ROMAN c.100 BC-AD 500

Most books on terracottas cover only Greek figures and do not include Roman, perhaps because Roman terracottas are comparatively rare and often somewhat ugly. After *c*. AD 100 production of terracottas everywhere started to decrease (bronze was preferred and becoming cheaper) and between *c*. AD 200 and 500 it gradually ceased altogether. Its demise was also due to the triumph of Christianity over all forms of paganism. Designs from the Roman era tended to be commonplace and were often indifferent copies of Greek originals. The two Aphrodites (94) are a case in point. The earlier of these still has a Hellenistic feel and is first century BC, she is shown tending her hair and busy at her

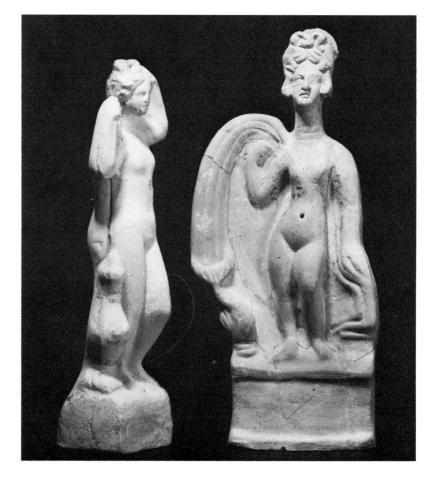

94 Two Aphrodites. Roman, (left) first century BC, (right) first century AD. Heights 21, 23 cm.

toilet, with an amphora at her side. The other is later, signed by her coroplast Mestos, and is certainly Roman and first century AD. She represents the birth of Aphrodite (or Venus in the Roman idiom) when she 'sprang from the foam of the sea' accompanied by the dolphin at her side. Both are pedestrian indeed as works of art, but the earlier Hellenistic figure is more graceful than the Roman.

The circular relief (95) is still Hellenistic, *c.* 100 BC, and probably shows Hercules molesting a maiden seated on his lion's skin cloak draped over a rock. Athene is to his right, with her spear and shield, protecting him during his dalliance. This little plaque is rather worn, but unusual in its shape. The Loeb Collection (Catalogue No. 113) included somewhat similar flat reliefs of Hercules found in Rome, and they echo the Campanian and Melian reliefs of the fifth century BC (47 and 53), and certain designs for mirror covers of the fourth century BC.

The Romans, of course, glorified war, and soldiers are a subject treated with enthusiasm. Plate 96 shows, on the right, a warrior with right arm raised; there is a hole in his fist presumably to take a spear

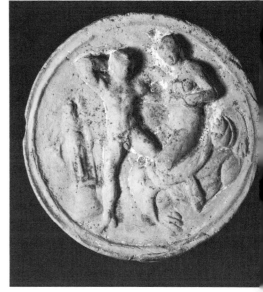

95 Circular relief, of Hercules. Roman, first century BC. Diameter 7.5 cm.

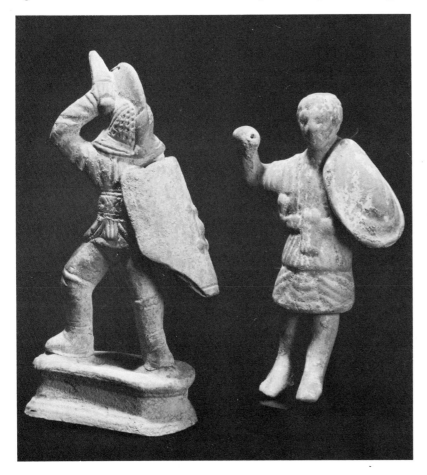

96 Two soldiers. Roman, first century AD. Heights 20, 18 cm.

and he also has a hole in the top of his head for suspension. His legs swing freely and he must have been a child's toy. The other warrior, on the left, is a Samnite gladiator, a rather splendid fellow wearing full gladiatorial regalia including a crested helmet, dagger in upraised right hand, knee-length boots and a large shield to ward off the other combatant.

Lastly, perhaps as a patriotic tail-piece, we have a Romano-British bird (97), made of white pipeclay, whose species escapes me but I imagine it is a duck or a goose. Such birds have been found in Colchester and other Roman camps and may have been made in France or Germany and imported.

97 Bird. Romano-British, first to second centuries AD. Height 8 cm.

7 FORGERIES AND DIVERS ADVICE

Most collections, private and public, contain undetected fakes. The previous chapters and plates will have told the reader what the genuine article looks like, and I hope now to arm him against the forgery. There are three main groups of fakes. Firstly, the bizarre forgery which is usually made of clay or plaster and painted gaudily in bright colours, the figure so garish and non-classical as to be an object only of derision. No dangers here. The next two groups are professionally made and decidedly a trap for the unwary.

Painted forgeries

The hardest to recognize are those that were made in the late nineteenth century, mainly 'Tanagras', to satisfy the avid collectors (chiefly French) whose appetites had been whetted by the genuine figures excavated after 1870. They are often very difficult to detect today with the patina and accretion of dirt that have developed with the passage of time. Original moulds were sometimes used and even local clay. But the forger invariably made the error of colouring his figures too brightly and the colours are hard, metallic and often fired instead of the muted fugitive tints on the genuine terracottas. Presumably their uninformed customers were attracted by the bright colours! We must be grateful to them, because otherwise detection would be even more difficult. Another flaw is in the wall thickness of the clay. In antiquity, the equipment used to produce terracottas was crude in the extreme. Moulds had to be thick and so had terracottas to resist cracking in firing; nineteenth century techniques could employ stronger moulds, often of plaster, and thin-walled terracottas could safely resist distortion. The genuine article is rarely thinner than $\frac{3}{16}''$ (5 mm) whereas the fake Tanagra is frequently about $\frac{1}{16}''$ (1.5 mm).

Forged terracottas made in the nineteenth century are also, in a literal sense, too good to be true. Ancient coroplasts were working with imprecise moulds and crude ovens, which were somewhat hit-or-miss in their results, whereas these modern forgers produced near-perfect figures with too well-defined facial features and garments. Plate 98 shows a figure in the British Museum. This 'Tanagra' has the tell-tale hard colours and thin clay, the eyes are almost etched in their precision and the himation drawn up over the head is too thin to be credible. Of course there are other faults. No Greek coroplast worth

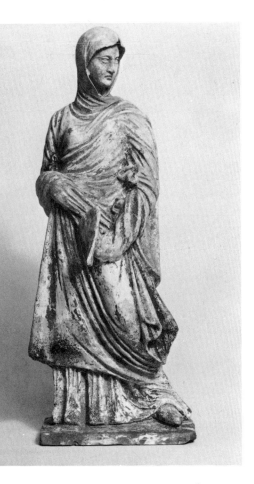

98 Standing woman. Modern.
Height 28 cm.

his salt as an artist would have stuck the fan straight out; he would have laid it flat against the body for maximum visual effect. Nor would he have given the face such a 'who goes there?' expression. Genuine Tanagras have a sightless gaze and express the inner spirituality present in all Greek art of quality.

Another nineteenth century group which was much faked was a whole class of elaborate mythological figures said to have come from Asia Minor about 1875. These exaggerated mythology to such a degree that one's antennae start to vibrate a warning when confronted with them. I once saw (from a very famous collection) a drunken Dionysus sprawled across the back of a boar in a manner that no Greek would have contemplated seriously, and, on another occasion, a pair of scantily clad goddesses leaning on a stele and beckoning the beholder to join them in decidedly non-religious observances. So beware of style.

Unpainted forgeries

Modern forgers tend to produce plain figures, detection being more difficult than with painted terracottas. Clay is, unfortunately, the most readily available of all materials and fakes coming out of the Mediterranean countries at present use local clay, sometimes covered with a white 'slip', but more often quite plain. When they use ancient moulds, we have an even greater problem.

Modern clay absorbs moisture more speedily than ancient; a rudimentary test that I use is to dampen the underside of a terracotta with spittle from the tip of my finger. An ancient figure will take a longish time to absorb it, a modern figure dries almost immediately. Another sign is the musty smell that comes off the genuine article when damped, whereas the modern fake remains comparatively odourless.

The unpainted forged terracotta may well have a faked deposit on it. One form of genuine deposit is a siliceous encrustation, which adheres quite tenaciously, whereas a modern deposit rubs away with the finger and probably consists only of sand and glue. I remember an intact nude Aphrodite being offered me in the Lebanon with such a sand deposit, which of course I refused, and I later saw it being hawked round dealers, now broken and repaired rather obviously to indicate its ancient burial and recent discovery.

The figure that is intact must be suspect. Only terracottas buried in individual graves or burial chambers were usually left intact in antiquity; those buried in trenches or sanctuaries were invariably broken up purposely so that they could not be re-used, and if found in and around villas or workshops, they only survived as fragments for the most part because of the natural fragility of a terracotta. Of course excavators retrieved all the parts of a figure wherever possible and joined them up, but these joins are fairly easy to detect and a sign of authenticity.

One must beware however of made-up figures. The head may have been faked, or it may, more likely, be a genuine head from a different figure. The value of a figure is not the sum of its parts, in that a complete terracotta is more valuable than separate heads and torsos, a fairly obvious fact perhaps that goes to explain the joining up of unrelated parts. These are difficult to detect, particularly Tanagra figures which are often similar in their designs. A magnifying glass is an essential aid to the purchase of terracottas, and the patina and 'slip' should be particularly studied at the neck–to see whether their appearance is similar above and below any join. Heads have frequently broken off and been rejoined, but you must try and ascertain that it rightfully belongs to the torso. It is, incidentally, no great discredit to a figure if it has been broken and the parts rejoined visibly and carefully, but 'make-up' with plaster or moist clay, which is then tinted, is an unforgivable transgression and, in my view, borders on forgery itself. Joins should be visible, infilling should be in a different coloured clay or plaster. Figures with large broken gaps are certainly unsightly and should be filled, but the extent of the repair should be left clear to the beholder. Missing features, such as arms or legs, should never be re-created to add to the value. The new part will almost certainly be recognizable as such anyway and then the entire figure will be condemned as suspect. An ultra-violet lamp will detect restoration but one's chances of using such an instrument before a purchase are usually remote.

To show that my own record is not unblemished, I reproduce, in plates 99 and 100, two forgeries in my own collection. To emphasize the difficulties in detection, and perhaps to take a measure of comfort in my mistakes, I should record that the seated lady was vetted and passed by an expert, and the Eros appeared on BBC television in a group of my figures! I hasten to add that at the time I did not know they were forgeries, and only a T.L. test (see below) revealed the awful truth to me.

Of course it is easy to be wise after the event and naturally I now see *why* they are fakes! Both were purchased in the early days of my collecting and I do not believe I would make the same mistakes again. The seated lady has the tell-tale, thin-walled clay and is a nineteenth century forgery, the Eros has unbelievably harsh blue and yellow colours behind the wings and is altogether too pretty a little rococo figure to be genuine. But both fakes are regrettably well done and serve to emphasize the difficulties that face us in detection.

T.L. tests
Testing by Thermoluminescence is only one of several analytical methods available nowadays but it is certainly the best for terracottas. The first laboratory was set up in the late 1960s in Oxford at the Re-

search Laboratory for Archaeology and the History of Art. Their success rate has led to leading museums installing their own laboratories to test their own acquisitions – not, anyway at present, objects shown them by the public for verification – and, before long, we may see all ancient clay objects from all regions and periods authenticated by this process. Perhaps some surprises lie in store for museum curators, who have been obliged to judge mainly by style, as technical aids verify or expose objects in their public collections.

T.L. tests have fairly recently exposed, amongst other things: Turkish 'Hacilar' figures at the Metropolitan Museum in New York, purporting to be 6000 BC, as modern forgeries; a group of 'Etruscan' painted panels, that cost their private owners over £100,000, as having been made in Italy within the last 10 years; 'Anatolian' vases and bowls, acquired by the Ashmolean Museum in Oxford, as modern; Chinese 'Tang' horses as modern; and, on a much more modest scale, terracottas in my collection shown in plates 99 and 100.

The method of testing relies on the fact that clay contains certain minerals that absorb and store energy when exposed to radiation. This radiation comes from the decay of radioactive elements that are always present in small concentrations. When the clay is originally fired, its stored energy is released or erased – putting the T.L. 'clock' back to zero as it were – but, immediately after firing, energy is again gradually stored up. This accumulated energy can be measured. Upon heating above 500°C, it is released in the form of light whose intensity is proportional to the number of years since the clay was fired. Simply stated, a small sample of recently fired terracotta would yield a low light intensity, when measured for thermoluminescence (indicating a short period of time for the storage of energy), but clay fired centuries ago would yield a high light intensity. The accuracy of dating is ± 10–25% depending on the size of sample taken from the object. A chunk is preferable, but delicate terracotta figures usually have a hole, $\frac{1}{16}''$ (1.5 mm) diameter and about $\frac{1}{8}''$ (3 mm) in depth, drilled in some unobtrusive position in the base or the back (these tiny holes can just be seen in plate 67). The drill also extracts the clay dust. The wide margin of error up to 25% is, in fact, unimportant as the date of the object being tested is likely to be over two thousand years old, if authentic, or less than one hundred years, if a forgery. A typical test result for a Tanagra figure gives the age as 'between fifteen and twenty-five hundred years' and a modern piece 'less than one hundred and fifty years' but these datings are sufficient for our purpose. If the object has been restored, the clay joins may be modern and it will then be necessary to sample in several places. A case in point was the mask (56) which, when first tested in a cleverly disguised join, showed up as modern, and my relief can be imagined when this fine piece proved to be ancient after a second test.

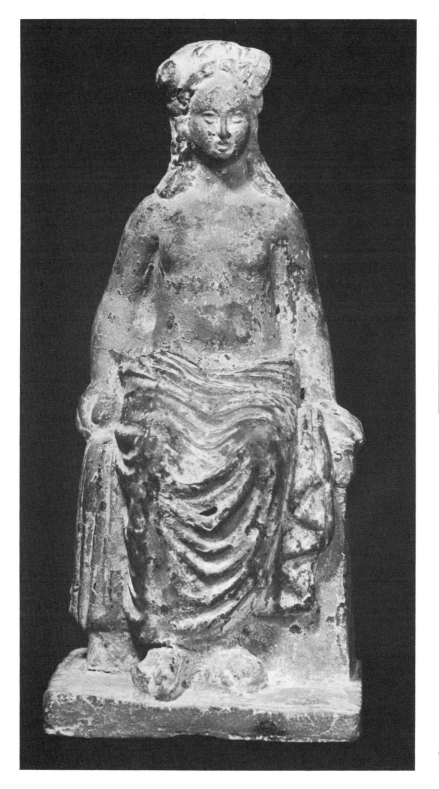

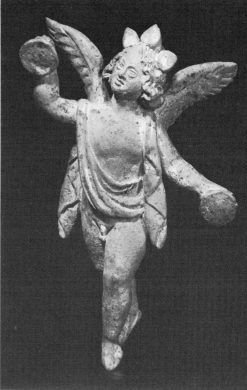

100★ Eros. Modern. Height 9.5 cm.

99★ Seated woman. Modern.
Height 14.5 cm.

The present charge by the Research Laboratory for Archaeology and the History of Art is up to £50 per object but they are always willing to consider testing for research rather than commercial reasons and adjust their fee accordingly. Christie's and Sotheby's increasingly ask people selling terracottas to allow their pieces to be tested so that sale entries can be supported by the guarantee of a T.L. test, wisely in my view because of the need to curtail forgeries. A buyer nowadays has greater legal protection than in the past and, if he purchases an object from a dealer or auction house and it proves to be a forgery (for instance by a T.L. test) within a certain time limit, the vendor is obliged to take it back and reimburse the purchaser in full.

Advice from museums

A collector or dealer in Great Britain may take terracottas, or indeed any antiques, to a museum specializing in the subject and obtain impartial advice as to their authenticity and provenance. It is not always so in other countries and we are indeed fortunate in being able to consult the experts. They do not allow their authentication of an object to be published (for instance, in a sale catalogue) but, in practice, a dealer or auction house will seek advice on a piece that is doubtful, thereby protecting both his reputation and the public from purchasing a forgery. This is an invaluable safeguard. I have always met with unfailing courtesy and patience from museum staffs and I would advise a collector, if practicable, always to try and obtain advice on a piece before he buys it. Creditable dealers will invariably allow such a preview, if they have not already submitted it themselves.

Preservation

Do-it-yourself cleaning and restoration of terracottas is not really to be recommended. They are best put in the hands of expert free-lance restorers whose names can be obtained from dealers. But, if a collector wishes to risk his own handiwork, he will want to deal with the removal of dirt and deposits, the separation of unsightly joins and re-sticking of parts more tidily, and the restoration of gaps, using modern clay or plaster, in a manner that is recognizable as modern but tasteful to the eye. However, before any attempt at full scale cleaning is carried out, it is advisable to select an inconspicuous part of the terracotta for testing purposes. Some ancient terracottas may have become friable and, in some instances, will break down completely when they come into contact with water. A small drop of water or the judicious use of a wet cotton wool swab in an unimportant area should give a fair idea of the durability of the clay or of any colours which may have survived. These colours are, in the main, either white chalk or coloured pigments produced by dyeing chalk mordants.

It is preferable to underclean rather than overclean a terracotta, otherwise the patina, slip or colours will disappear to the detriment of appearance and value of the object. Soaking in softened water for a few hours plus gentle brushing with a sable-hair artist's brush will remove most surface dirt, but if stubborn deposits remain these may be removed with a 5–10% diluted hydrochloric acid applied to the terracotta which must be soaked in water first. Calcium carbonate (or lime) deposits will effervesce in dilute hydrochloric acid or nitric acid until the deposit has disappeared, but again it is of vital importance that any surviving colours are not destroyed at the same time. Crushed shell fillers may have been used in the clay and the destruction of these in acid could mean serious loss of strength, or even total collapse, of the terracotta. When used, the acid must be removed by soaking the object in several changes of clean water. A figure is best supported by sponges in a dish of water.

Old joins will sometimes come apart in water, otherwise acetone should do the trick. After cleaning off the parts they can be restuck using one of the lighter cement compounds – better than animal glue which can be unsightly and unreliable. Modern irreversible resins such as epoxy or polyester are not recommended. Adhesives should be capable of being dissolved easily with solvents such as acetone, in the event of things not going quite according to plan.

Gaps can be filled with plaster or clay of a different colour from the original; clay, however, shrinks upon drying and is not very strong. If a large gap is to be filled, a mould can be made in plasticine or dental wax using a curve of equal form to that of the existing figure. Infilling in this way can be made easier by sitting the parts to be joined in a box of sand to ensure no movement occurs whilst drying off.

Records

Always catalogue your figures with a photograph and full description. Copies should be lodged with your insurance company or bank so that, if your house and collection are burned down, you have a record for the art historian who comes after you. This will also avoid arguments in claiming insurance. Photographs may be necessary in helping the police if you are burgled, though terracottas are of doubtful value to a burglar in view of their fragility and comparative rarity. Insurance costs need not be excessive if you persuade the broker that only the owner handles the figures and that they are kept in locked glass cabinets at all times. If they go out for exhibition, terracottas must be separately insured.

Presentation

Gone are the days, happily, when terracottas were displayed in museums

in serried ranks like so many toy soldiers. Nowadays we find them presented, a few at a time which is the secret of all good display, against tasteful backcloths of neutral colours with lighting above and below – never at the side as this throws a shadow. Personally I have display cabinets with velvet backgrounds and sides in pastel shades of blue, green and light red; colours which throw the clay into relief but do not over-ride it. Display cabinets should have adjustable shelves to accommodate any larger figures that you may acquire. Masks and protomes look best wall-mounted; erotes like to fly suspended by a strong cotton. A hand mirror behind a piece is helpful for viewing in the round; spare mounts coloured in the same cloth as the cabinet can vary the heights of figures, which makes for variety. Fun can be had with a small spotlight, especially if you put a single figure into a compartment. Group your figures according to periods and regions.

Terracottas should always be kept behind glass. They dislike dust and strong sunlight and, of course, their fragility demands that they are not just placed on an open shelf or mantelpiece. 'Dust' them by blowing it off (out of the window if you want to avoid a row with your wife). Never use a duster as there is no cloth soft enough not to damage fractionally the surface. Always handle figures with both hands and only one figure at a time. Never pick them up by a head or an arm – it may snap off. Put them down gently. When taking them out or replacing them in their display cabinets, beware of the shelf above. Remove your coat, if you are handling a lot of them, or your sleeve may brush one accidentally. Tuck in your tie for the same reason. If these counsels appear banal and self-evident, I can only say that I have had accidents at different times due to all these causes.

Mounts should either be in clear plastic or wood painted black (the better of the two I think). Natural wood tends to clash with the colour of the clay and is less satisfactory.

DEALERS

This list comprises only those dealers in classical antiquities who are known to me and whom I have personally found to be reliable, although I cannot, of course, guarantee the authenticity of any pieces that may be purchased. Classical antiquities are a wide field, but the dealers mentioned usually have some terracottas in stock. Christie's and Sotheby's have regular sales of antiquities in the winter season and there are usually some terracottas included.

France
Paris

A la Reine Margot, 7 Quai de Conti
Hindamian, 14 Rue des Pyramides
Collection Mikas, 86 Rue de l'Université
Charles Ratton, 14 Rue Marignan
Galerie Segredakis, 4 Rue de l'Echelle

Germany
Munich

Herzer, Promenadenplatz
Lindner, Elektrastrasse 17

Great Britain
London

Coins and Antiquities Ltd, 76 New Bond Street
Charles Ede Ltd, 37 Brook Street

Holland
Amsterdam

Schulman N.V., Keizersgracht 448

Switzerland
Basle

Münzen und Medaillen A.G., Malzgasse 25
Zurich

Galerie Arete, Augustinergasse 15
Jeannette Brun, Dufourstrasse 119
Galerie Heidi Vollmoeller, Kurhausstrasse 17

United States of America
New York

J. J. Klejman Gallery, 982 Madison Avenue
Komor Gallery, 19 East 71 Street

PUBLIC COLLECTIONS

Examples of terracottas can be found in many minor provincial museums throughout Europe and America but I have attempted below to list those that have major collections. Until about 1880 the governments of Mediterranean countries where antiquities were to be found permitted a part of those excavated to be retained by the country or person organizing the dig—hence the national museums in London, Paris, Berlin and New York are rich in terracottas. Thereafter any figures that were added had to be bought or were bequeathed. Latterly museums in Greece and the Greek Islands, Egypt, Italy and Turkey have increased their collections enormously, securing for themselves quite rightly the terracottas that have been excavated. Local museums in these countries have frequently been built expressly to house local discoveries and excellent collections can be seen in Heraclion (Crete), Sicily, Taranto, Olympia, Delphi, Pergamon, Corinth, etc.

Belgium
Brussels
Cinquantenaire Museum
(Musée Royal d'Art et
d'Histoire)

Denmark
Copenhagen
National Museum
Ny Carlsberg Glyptotek

Egypt
Alexandria
Graeco-Roman Museum

France
Paris
Bibliothèque Nationale
Louvre

Germany
Berlin (East and West)
City Museums

Hamburg
Museum für Kunst und
Gewerbe

Great Britain
Cambridge
Fitzwilliam Museum
London
British Museum
Newcastle
University Museum
Oxford
Ashmolean Museum

Greece
Athens
Agora Museum
Akropolis Museum
National Museum

Holland
Amsterdam
Allard Pierson Museum

Italy
Naples
National Museum
Rome
Villa Guilia

Russia
Leningrad
Hermitage Museum

Spain
Madrid
Archaeological Museum

Switzerland
Basle
Antikenmuseum

Geneva
Musée d'Art et d'Histoire
Zurich
Archaeological Institute

Turkey
Istanbul
National Museum

United States of America
Boston
Museum of Fine Arts
New York
Metropolitan Museum

BIBLIOGRAPHY

G. D. BELOW

Terrakoty Tanagry (Leningrad, 1968). Tanagras in the Hermitage Museum, text in Russian and English.

N. BREITENSTEIN

Catalogue of the Terracottas in the Danish National Museum (Copenhagen, 1941). Unfortunately out of print.

R. A. HIGGINS

Catalogue of Terracottas in the British Museum (British Museum 1963). 2 vols. Encyclopaedic to 330 BC. Further volumes to follow.

R. A. HIGGINS

Greek Terracottas (London, 1967). The most definitive book in English in print today.

R. A. HIGGINS

Greek Terracotta Figures (British Museum, 1963). An excellent short introduction to the subject.

H. HOFFMANN

Collecting Greek Antiquities (New York, 1971). A most readable work with a chapter on terracottas.

S. MOLLARD-BESQUES

Catalogue Raisonné des Figurines et Reliefs en Terre-cuite, Grecs, Etrusques et Romains (Louvre, Paris, 1954 and 1963). Vol. 1 covers figures up to the Hellenistic period, Vol. 2 covers Myrina figures, both volumes are divided into two (plates and descriptions) and are the official catalogues of the Louvre collections. Further volumes are to follow.

S. MOLLARD-BESQUES

Les Terres Cuites Grecques (Paris, 1963). The best general book in French, still in print, with many examples from the Louvre.

F. NICHOLSON

Greek, Etruscan and Roman Pottery and Small Terracottas (London, 1965). A good, brief guide.

F. NICHOLSON

Ancient Life in Miniature (Birmingham, 1968). Covers an exhibition of terracottas from private collections in England.

E. POTTIER

Diphilos et les modeleurs de Terres Cuites Grecques (Paris, 1931). By the great French archaeologist, a tour of the Louvre terracottas. Out of print.

G. M. A. RICHTER

Greek Art, a Handbook (London, 1959). Contains an excellent chapter on terracottas, good bibliography.

G. M. A. RICHTER

Handbook of the Greek Collection (Metropolitan Museum of Art, New York, 1953). No catalogue yet exists of the collection of terracottas in the Metropolitan, but many of their best pieces are included in this handbook.

E. ROHDE

Griechische Terrakotten (Tübingen, 1959). Excellent photographs, some in colour, of 60 terracottas from the City Museum in East Berlin.

J. SIEVEKING

Die Terrakotten der Sammlung Loeb (Munich, 1916). 2 vols. An important source book, out of print.

V. VERHOOGEN

Terres Cuites Grecques aux Musées Royaux d'Art et d'Histoire (Brussels, 1956). A short guide to the Museum Collection.

C. VERMEULE

Greek, Etruscan and Roman Art (Boston, 1963). No catalogue yet exists of the collection of terracottas in the Museum of Fine Arts in Boston, but many of their best pieces are included in this handbook.

D. VON BOTHMER AND J. V. NOBLE

An Inquiry into the Forgery of the Etruscan Terracotta Warriors (Metropolitan Museum of Art, New York, 1961). Paper No. 11 from the Museum which describes the revelation of these superb forgeries.

R. B. L. WEBSTER

Greek Terracottas (Harmondsworth, 1950). One of the excellent little King Penguin series, now alas out of print.

F. WINTER

Die Typen der Figürlichen Terrakotten (Berlin, Stuttgart, 1903). 2 vols. A comprehensive work, out of print.

LIST OF PLATES

British Museum, London. Cat. No. B.7. Height 10 cm. (*British Museum*)

9 Ploughing Group. Mycenaean, *c.* 1400–1200 BC. Author. Cat. No. 117. Height 9 cm.

10 Standing goddess with child. Mycenaean, provenance Mycenae, tomb 40, excavated 1887–8, *c.* 1400–1200 BC. National Archaeological Museum, Athens. Cat. No. 2493. Height 13 cm. (*Tap Service*)

11 Seated goddess on throne. Mycenaean, *c.* 1400–1200 BC. The late Lady Norton. B. No. 15. Height 6.5 cm.

12 Doll. Boeotian, late eighth century BC. Museum of Fine Arts, Boston, ex E. P. Warren Collection. Cat. No. 98.891. Height 30 cm (without legs 23.5 cm). (*Museum of Fine Arts*)

13 Two 'Snowmen' figures. Cypriot, *c.* 700 BC. Author. Cat. Nos. 83, 84. B. Nos. 226, 227. Heights 14, 10 cm.

14 Standing goddess. Cypriot, seventh century BC. Author. Cat. No. 99. Height 19.5 cm.

15 Dedalic plaque. Cretan, mid-seventh century BC. British Museum, London. Cat. No. 586. Height 14 cm. (*British Museum*)

16 Dedalic plaque. Cretan, mid-seventh century BC. Ashmolean

Museum, Oxford. Cat. No. G.484. Height 15 cm. (*Ashmolean Museum*)

17 Mourning woman. Rhodian (?), early sixth century BC. Allard Pierson Museum, Amsterdam. Cat. No. 230. Height 21 cm. (*Allard Pierson Museum*)

18, 19 Standing goddess (perfume bottle). East Greek, mid-sixth century BC. Author. Cat. No. 132. Height 19 cm.

20 Standing goddess. East Greek, mid-sixth century BC. British Museum, London. Cat. No. 58. Height 25.5 cm. (*British Museum*)

21 Seated goddess. East Greek, late sixth century BC. Author. Cat. No. 43. B. No. 24. Height 15 cm.

22 Two standing goddesses. Boeotian, early sixth century BC. Author. Cat. Nos. 85 (B. No. 57), 141. Heights 16, 9.5 cm.

23 Horse and rider. Boeotian, mid-sixth century BC. Author. Cat. No. 125. Height 13 cm.

24★ Squatting Monkey. Boeotian, mid-sixth century BC. Author. Cat. No. 104. Height 7.5 cm.

25★ Chariot group. Boeotian, sixth century BC. Author. Cat. No. 61. B. No. 61. Height 10.5 cm.

26 Horse and rider. Cypriot, seventh century BC. Museum of Fine Arts, Boston, ex Cesnola Collection. Cat. No. 72.140.

Height 22.5 cm. (*Museum of Fine Arts*)

27 Three heads. Cypriot, sixth century BC. Author. Cat. Nos. 133, 88 (B. No. 221), 74 (B. No. 216). Heights 5.5, 4, 6 cm.

28 Female protome. Rhodian, *c.* 500 BC. Author. Cat. No. 108. Height 12 cm.

29 Pig, boy on turtle, tortoise. Rhodian, fifth century BC. Author. Cat. Nos. 33 (B. No. 37), 73, 32 (B. No. 34). Heights 5, 4.5, 3.5 cm.

30 Boar with cake in mouth. Boeotian, early fifth century BC. Author, ex Lanckoronska Collection. Cat. No. 37. B. No. 72. Height 5 cm.

31 Woman feeding hens and chicks. Boeotian, early fifth century BC. The late Lady Norton. B. No. 73. Height 12.5 cm.

32 Dog with cake in mouth and bird on back. Boeotian, early fifth century BC. Girton College, Cambridge. B. No. 71. Height 7.5 cm.

33 Woman cooking. Boeotian, *c.* 500 BC. Staatliche Museen, Berlin. Cat. No. 31.464. Height 10 cm. (*Staatliche Museen*)

34 Standing woman. Boeotian, mid-fifth century BC. Author. Cat. No. 5. B. No. 74. Height 23 cm.

35 Standing youth. Boeotian, mid-fifth century BC. Author. Cat. No. 140. Height 26 cm.

36★ Standing youth. Boeotian, mid-fifth century BC. Author. Cat. No. 60. B. No. 76. Height 26 cm.

37 Banqueter. Attic, early fifth century BC. Author. Cat. No. 46. B. No. 27. Height 6.5 cm.

38 Reclining woman. Attic, early fifth century BC. Staatliche Museen, Berlin. Cat. No. 8256. Height 15.5 cm.
(Staatliche Museen)

39 Two comic actors. Attic, mid-fourth century BC. Author. Cat. Nos. 40 (B. No. 49), 134. Heights 9, 8 cm.

40 Comic actor. Attic (?), mid-fourth century BC. Fitzwilliam Museum, Cambridge, ex Collection formed by D. S. Ricketts and C. H. Shannon. Cat. No. GR85e. 1937. Height 11 cm.
(Fitzwilliam Museum)

41 Standing and seated figures of Demeter. Corinthian, c. 500 BC. Author. Cat. Nos. 130, 113. Heights 17.5, 17.5 cm.

42 Articulated doll. Corinthian, early fifth century BC. Fitzwilliam Museum, Cambridge. Cat. No. GR44. 1952. Height 13.5 cm.
(Fitzwilliam Museum)

43 Two heads of Dionysus. Tarentine, early fifth century BC. Author. Cat. Nos. 71 (B. No. 222), 98. Heights 9, 9 cm.

44 Mask. Tarentine (?), c. 500 BC. Author. Cat. No. 26. B. No. 187. Height 12 cm.

45★ A pair of shoes (? perfume bottles). Etruscan, early fifth century BC. Author. Cat No. 81. Heights 14, 10 cm, lengths 23, 23 cm.

46 Bull's head. South Italian, mid-fifth century BC. Author. Cat. No. 82. Height 10.5 cm.

47 Relief of satyr. Campanian, fifth century BC. Author. Cat. No. 70. Height 4 cm.

48★ Seated woman. Sicilian, early fifth century BC. Author. Cat. No. 126. Height 20.5 cm.

49★ Two female protomes. Sicilian, fifth century BC. Author. Cat. Nos. 120, 36. Heights 15, 17 cm. (Only the left hand figure was T.L. tested.)

50 Seated woman and child. Sicilian, early fifth century BC. Author. Cat. No. 22. B. No. 85. Height 9 cm.

51 Female head. Sicilian, fourth century BC. Author. Cat. No. 38. B. No. 86. Height 17.5 cm.

52 Miniature standing goddess. Cretan, late fifth century BC. Author. Cat. No. 48. B. No. 19. Height 6.5 cm.

53 Relief. Melian, mid-fifth century BC. Allard Pierson Museum, Amsterdam, ex Collection Scheurleer. Cat. No. 267. Height 15 cm.
(Allard Pierson Museum)

54 Bust of a man. Attic, second

century BC. Author, ex De Clercq Collection. Cat. No. 76. Height 9 cm.

55★ Eros on two peacocks. Attic, third century BC. Author. Cat. No. 111. Height 13 cm.

56★ Comic mask. Attic, second century BC. Author, ex De Clercq Collection. Cat. No. 119. Height 20 cm.

57 'Ephedrismos' group. Attic (?), third century BC. Allard Pierson Museum, Amsterdam. Cat. No. 313. Height 43 cm.
(Allard Pierson Museum)

58★ Standing woman. Attic, late fourth century BC. Author. Cat. No. 53. B. No. 123. Height 15.5 cm.

59★ Standing boy, standing woman, seated youth. Boeotian (Tanagra), c. 330–200 BC. Author. Cat. Nos. 59 (B. No. 101), 23 (B. No. 95), 16 (B. No. 113). Heights 16.5, 17.5, 17 cm. (All three figures T.L. tested.)

60★ Standing woman, standing woman, seated boy, standing woman. Boeotian (Tanagra), c. 330–200 BC. Author. Cat. Nos. 17 (B. No. 116), 138, 34 (B. No. 89), 129. Heights 17, 18, 13, 17 cm. (Only Cat. Nos. 34 and 129 T.L. tested.)

61 Head showing 'melon' coiffure. Boeotian (Tanagra), c. 330–200 BC. Author. Cat. No. 23. B. No. 95. (See plate 59 for whole figure.)

62 Standing woman. Boeotian
(Tanagra), *c.* 330–200 BC.
Metropolitan Museum of Art,
New York, gift of Mrs Sadie
Adler, May 1930. Cat. No. 30.117.
Height 30.5 cm.
(Metropolitan Museum of Art)

63 Standing woman, called *La
Sophocléenne*. Boeotian (Tanagra),
c. 330–200 BC. Musée du Louvre,
Paris. Cat. No. MNB.585.
Height 30 cm.
(Chuzeville)

64, 65 Group of two standing
women. Boeotian (Tanagra),
c. 330–200 BC. Girton College,
Cambridge. B. No. 105. Height
21.5 cm.

66★ Athlete. Boeotian (Tanagra),
c. 330–200 BC. Author, ex De
Clercq Collection. Cat. No. 93.
Height 28 cm.

67★ Vent holes, bases and holes
for T.L. tests. Author. The figures
illustrated are Cat. Nos. 59 (see
plate 59), 129 (60), and 16 (59).

68★ Standing woman.
Alexandrian, third century BC.
Author. Cat. No. 18. B. No. 154.
Height 30 cm.

69 Standing woman. Alexandrian,
third century BC. Author. Cat. No.
19. B. No. 156. Height 15 cm.

70 Seated woman. Alexandrian,
third century BC. Author. Cat. No.
121. Height 15 cm.

71 Seated actor. Alexandrian,
third century BC. Author. Cat. No.
91. Height 14.5 cm.

72 Comic mask. Alexandrian,
first century BC. Author. Cat. No.
86. B. No. 190. Height 18 cm.

73★ Seated woman with kithara.
South Italian, *c.* 330–200 BC.
Author. Cat. No. 39. B. No. 127.
Height 19 cm.

74★ Standing woman. South
Italian, *c.* 330–200 BC. Author, ex
Lowe Collection. Cat. No. 127.
Height 22.5 cm.

75 Standing woman. South
Italian, third century BC. Author.
Cat. No. 58. B. No. 130. Height
21.5 cm.

76 Satyr and maenad. Sicilian,
c. 150 BC. Antikenmuseum, Basle.
Cat. No. 185,2. Height 29 cm.
(Antikenmuseum)

77 Male head. South Italian, *c.* 100
BC. Author. Cat. No. 114. Height
15 cm.

78★ Eros. Tarentine, third
century BC. Author. Cat. No. 102.
Height 18.5 cm.

79 Standing woman. Tarentine,
third century BC. Author. Cat No.
136. Height 21 cm.

80 Profile head of youth.
Etruscan, third century BC.
Author. Cat. No. 80. B. No. 242.
Height 23.5 cm.

81 Female head. Etruscan, third
century BC. Author. Cat. No. 12.
B. No. 243. Height 21.5 cm.

82★ Eros. Myrinan, second
century BC. Author, ex De Clercq

Collection. Cat. No. 118. Height
14 cm.

83 Nike, with mask. Myrinan,
second century BC. Museum of
Fine Arts, Boston, ex E. P.
Warren Collection. Cat. No.
01.7706. Height 26.5 cm.
(Museum of Fine Arts)

84★ Aphrodite. Myrinan, second
century BC. Author. Cat. No. 107.
Height 15 cm.

85 Doll. Myrinan, second century
BC. Author, ex-Lanckoronska
Collection. Cat. No. 78. B. No.
140. Height 16.5 cm.

86 Crouching Aphrodite.
Myrinan, second century BC.
J. Paul Getty Museum, Malibu.
Cat. No. A57.S-6. Height 22 cm.
(J. Paul Getty Museum)

87 Mask of a youth. Myrinan,
second century BC. Author.
Cat. No. 105. Height 11 cm.

88 Grotesque head, Smyrnan,
second century BC. Author, ex
Spencer-Churchill Collection.
Cat. No. 135. Height 6.5 cm.

89 Two grotesque heads.
Smyrnan, second century BC.
Author, ex De Clercq Collection.
Cat. No. 94. Height 7 cm.

90 Negro boy clasping amphora.
Asia Minor, second century BC.
Author. Cat. No. 20. B. No. 142.
Height 8 cm.

91 Group of heads. Hellenistic,
third or second centuries BC.

Author. Various Cat. Nos. and heights (average 5 cm).

92 Group of heads. Hellenistic, third or second centuries BC. Author. Various Cat. Nos. and heights (average 5 cm).

93 Female head. Hellenistic, third century BC. Author. Cat. No. 116. Height 3.5 cm.

94 Two Aphrodites. Roman, (left) first century BC, (right) first

century AD. Author. Cat. Nos. 101, 139. Heights 21, 23 cm.

95 Circular relief, of Hercules. Roman, first century BC. Author. Cat. No. 143. Diameter 7.5 cm.

96 Two soldiers. Roman, first century AD. Author. Cat. Nos. 28, 50. B. Nos. 180, 179. Heights 20, 18 cm.

97 Bird. Romano-British, first or second centuries AD. Author.

Cat. No. 75. B. No. 185. Height 8 cm.

98 Standing woman. Modern. British Museum, London. Cat. No. 1907-3-14.4. Height 28 cm. *(British Museum)*

99★ Seated woman. Modern. Author. Cat. No. 2. Height 14.5 cm.

100★ Eros. Modern. Author. Cat. No. 10. Height 9.5 cm.

INDEX

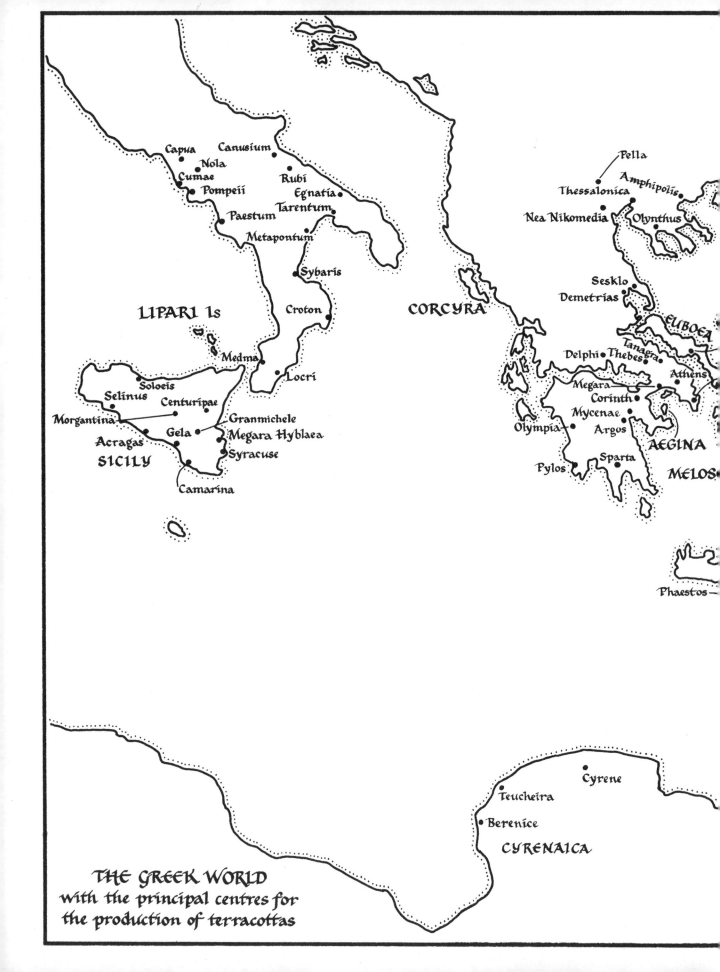

Capua
Canusium
Nola
Cumae
Pompeii
Paestum
Rubi
Egnatia
Tarentum
Metapontum
Sybaris
Croton

LIPARI Is

Medma

Soloeis
Selinus
Centuripae
Morgantina
Gela
Granmichele
Megara Hyblaea
Acragas
Syracuse
SICILY
Camarina

Locri

CORCYRA

Pella
Thessalonica
Amphipolis
Nea Nikomedia
Olynthus

Sesklo
Demetrias
EUBOEA
Delphi
Tanagra
Thebes
Megara
Athens
Corinth
Mycenae
Olympia
Argos
AEGINA
Sparta
MELOS
Pylos

Phaestos

Cyrene
Teucheira
Berenice
CYRENAICA

THE GREEK WORLD
with the principal centres for
the production of terracottas